BILL RILEY
on the Air AND AT THE
IOWA STATE FAIR

BILL RILEY
on the Air AND AT THE
IOWA STATE FAIR

BILL RILEY SR. *with* HEATHER TORPY

THE
History
PRESS

Published by The History Press
Charleston, SC
www.historypress.net

Copyright © 2016 by Bill Riley Sr. and Heather Torpy
All rights reserved

Cover image courtesy of Iowa Public Television.

First published 2016

Manufactured in the United States

ISBN 978.1.46713.652.5

Library of Congress Control Number: 2016932973

Notice: The information in this book is true and complete to the best of our knowledge. It is offered without guarantee on the part of the author or The History Press. The author and The History Press disclaim all liability in connection with the use of this book.

CONTENTS

CONTENTS

FOREWORD

For us Iowans, this book is bread and butter; for those from elsewhere, it's perhaps an acquired taste. Here is a taste.

Full disclosure: In 1955, as a ten-year-old Cub Scout, I won the bubble gum–blowing contest on KRNT-TV's after-school *Bill Riley Show*, thus taking home the most incredible string-pulled, humming, spinning, flying toy I have ever seen before or since. I still think about it—the toy, I mean.

So fifty-five years later, I was primed to read the galleys of Mr. Riley's latest book, taking us on his long journey through radio and early television and his evolving role as public announcer, host of multiple Iowa venues and Iowa icon. We Iowans are fortunate that this son of Iowa and lifelong Iowa devotee took the time to share his recollections. I finished reading only wishing there were more.

The words in the book are Riley's own, composed in the last two years of his life while still mentally sharp but physically failing, as he could see "the great curtain in the sky, slowly descending." Minimal editing by his five children, carefully preserving their own miscreancies, is barely noticeable.

The format is familiar: a series of vignettes, like *Thunderbolt Kid* and in the same town and even the same time period. Only more mature and enduring. And with pictures.

The first half of the book, roughly chronological, lets us know somewhat succinctly how Riley got to be in the right place at the right time. This part alone is worth the read, just to peek inside the early local TV business, to be present at the creation, but especially to see how Riley landed where

he did and how it worked for him. It wasn't done overnight, as Riley and KRNT had to feel their way; in fact, it was actually quite difficult but fascinating. Here you get the details on an unending series of innovative live TV programs. Apparently, at the beginning and for several years, there was no videotape, so all local programming was live. In this environment, some interesting things could happen, and only the nimble and creative could survive. Riley proves to be the consummate survivor.

Ideas seemed to flow from his fingers. For instance, eBay had nothing on him—he perfected the on-line auction concept using a primitive phone line. His *Battle of the Bands* was just *American Idol* writ small and local. The public response to his early live TV programs gave the local phone company its first experiences with circuit overload. He was a master networker before networking was defined.

The second half of the book is an exploration of relationships and experiences with others in the profession and community. Many are familiar names to us Iowans, but they would be familiar types to people everywhere.

Entertainers, politicians, restaurateurs, philanthropists, future presidents and media personalities are all represented. Even more so are the work-a-day folk who grind out the results and make it all happen. Riley brings them to the forefront and extols their behind-the-scenes contributions and often as not just describes their very survival.

Several themes, never explicitly stated by Mr. Riley but mentioned by others recruited to provide contemporary reflection, emerge early. One is the striking energy of this man. He moved from program to program, project to project, clearly a man in his element. Just reading the first nine short chapters of the book will make you tired.

Another thread is how much he loved what he did. It was a seven-day-a-week, into-the-night job, commonly without financial reward. You get the impression that if he didn't need to support a wife and five children he would have done it all for nothing. You also hear a lot about the wife and children and appreciate his reasons for doing it all.

But central to the whole deal, at the middle of virtually every effort was... the youngsters. Not in the modern way, where every politician at every level is "doing it all for the children." It didn't seem to me that Riley "did things for children." Instead, he involved them. He involved them by the thousands, again and again. He recruited them as individuals, one after another after another. He brought them along. He expected them to do things for all of us and for themselves. Clearly, he respected them, and they responded overwhelmingly.

There's not much here about the statewide talent program he developed—and deliberately so, as it is part of another book—but he alludes to this monument to his life's work often enough that a novitiate will get the picture.

Looking at the many photos over the years, you realize that his stage persona never changed. You always knew what you would get with Riley. Eyes were bright, always looking up (he was short!), always a near smile or full smile, forever positive, never a flash of anger, no condescension. His sense of humor, as least in public, was broad and inclusive, and that comes through in the book as well. If he was ever disappointed, he never showed it, and he doesn't now either.

I didn't know anything about Mr. Riley's politics, but loud and clear in his writing comes the message that energy and hard work are key; that if something is to get done, then someone must do it; and that relationships are important.

In this modern time of bailouts and stimulus packages, of increasing dependence on government at every level, it is refreshing to see what one individual could do, as second nature, without a forethought, without thought of reward. It probably never occurred to Riley to look for a government grant or to turn to a bureaucracy for a project.

Reflecting on what I read in the galleys, I long for a prequel. I would love to see the details of the mixture of ethnicity, parenting, community, friends, siblings, schooling, play, work, Great Depression, war, peace and love that produced this remarkable man. There were many others of his midwestern generation with the same background and stature, but few had the opportunity to play so long and so well on the stage of life and set such an example.

One of his employers says in the book, "We'll conquer the world!" Well, maybe, maybe not. But most certainly it would be a better world, and with his example so subtly caught and interwoven on these pages, perhaps any reader could become more of a Bill Riley.

BOB SHRECK

Dr. Shreck completed his undergraduate work at the University of Iowa, where he majored in pre-medical studies in 1971. He graduated from the University of Iowa Medicine in 1974. Dr. Shreck completed a residency at the University of Utah School of Medicine, in 1977. He also completed a fellowship in medical oncology and hematology at the University of Utah School of Medicine in Salt Lake City, Utah, in 1979.

Dr. Shreck is certified by the American Board of Internal Medicine in internal medicine and medical oncology. He and his wife returned to his hometown of Des Moines, Iowa, in 1979 to begin practicing medical oncology and hematology at Iowa Methodist Medical Center. He was medical director of the Blood Center of Central Iowa from 1979 to 1983.

Dr. Shreck enjoys his farm home in Decatur County, Iowa, and the lakes of Minnesota. He and his wife have two sons and one daughter. He is also an avid ultra-light aircraft aficionado.

PREFACE

Bill Riley passed away peacefully in a care center in Scottsdale, Arizona, on December 15, 2006. He was eighty-six years old. The book you are about to read was a project he had worked on for a few years. Although a very accomplished typist, he wasn't comfortable with a computer, so most of this project was written by hand and then entered into a word format by my sister, Terri Masteller. That is where things began to really pick up steam. As Terri and I would read through his notes and scribbling, we found ourselves reliving a lot of our childhood. Things that we took for granted all of a sudden were much bigger than we had realized. His presence at the beginning of radio, television, public television and, later, cable television is quite remarkable. He loved his hometown of Iowa Falls as much as any person I know. He was passionately dedicated to the youth of the state and was instrumental in getting many youngsters outside their comfort zones. He worked very hard on making Iowa a better place and knew that Iowans were the key to that end.

I want to thank you for taking time from your busy schedule to read about a young man from Iowa Falls. I hope you have as much fun reading this remembrance as we had putting it together. As I write this, we are preparing for the 2016 talent show season with great anticipation.

Of all of his "projects," the talent show was by far his most cherished. I'm sure he never thought it would last fifty-seven years and counting. I do know he would be so happy that Hy-Vee, the employee-owned grocery store with which all Iowans are familiar, became our presenting sponsor

in 2013. Hy-Vee support has been a tremendous asset to the program and is the reason we are still able to continue the *Bill Riley Talent Search* to this day.

One of the funniest things he ever said to me was after I had taken over the emcee position for the talent show at the state fair. He said, "You know, this is a really fun show to watch." It was then that I realized that for almost fifty years, he really never was able to sit and watch. I know he's watching every show now, and as he loved to say, "I'll see you at the fair!"

BILL RILEY JR.

Thank you to Bill Riley Sr. for putting his memories to paper. His experiences are one of a kind, and yet at the same time, many Iowans will relate to his stories. Many of you reading this may have been on *Variety Theater* or were members of the *Breakfast Club*. Or maybe you performed in the *Bill Riley Talent Search* or have a child or grandchild currently performing in the *Talent Search*.

Although I didn't know Bill Sr. well, every time I saw him or recorded television promotions with him, he was sincere, kind and professional. I walked away from each interaction with a smile on my face.

When Bill Jr. asked me to take on the task of editing this book, I was elated. Having worked at KCCI and having a husband who works for Iowa Public Television, it was especially fun to read about Bill's time at each of those stations. And of course, now working for Bill Jr. and the *Bill Riley Talent Search*, I enjoyed the stories from the Iowa State Fair just as much.

Please keep in mind that Bill wrote this book in the last few years of his life, and we have tried to preserve his words as much as possible. Because of this, there are some things that have changed in the last ten years. For instance, at the time Bill was writing this book, Terry Rich indeed was the CEO of the Blank Park Zoo but has since become the CEO of the Iowa Lottery. Also, the Bill Riley Stage at the Iowa State Fair is now the Anne and Bill Riley Stage.

Thank you for taking the time to buy this book and relive some of Iowa's broadcast and state fair history.

HEATHER TORPY

ACKNOWLEDGEMENTS

Special thanks go out to the following people for their early support of this book: to the *Times-Citizen* staff in Iowa Falls for their preliminary work and editing; to Mary Feldman for proofreading and editing and for always reminding me what really matters—love this gal; to Paul Kirpes for setting preliminary goals and layout and always pushing for results; and to my sister, Terri Masteller, for transcribing Dad's chicken scratches.

But by far, my greatest appreciation goes to Heather Torpy for her dedication, guidance and help in making this "dream" of Bill Riley Sr. a reality. Simply stated, this book would not exist without Heather Torpy.

BILL RILEY JR.

Thank you to everyone who took the time to write letters and share your memories for this book. Your stories add another wonderful element to this great book of Bill's.

Thank you to all the children, parents, coordinators and Iowa State Fair staff; our presenting sponsor, Hy-Vee; and, of course, Bill Jr., who have kept the *Bill Riley Talent Search* alive for fifty-seven years and counting. Bill Sr.'s legacy truly lives on through each of you.

Thank you to Bill Jr., Ed, Terri, Pat and Peg for trusting me with your dad's words. I am honored to have had a part in this project.

Acknowledgements

Thank you to Ben Gibson and the staff at The History Press for believing in this project and guiding me through the process.

Most of all, thank you to my family for supporting me throughout the adventure of getting a book ready for publication. My husband, John, helped to keep Aiden and Claire occupied when I needed to work. My parents, Dave and Bobbi Schrader, were always willing to step in and take care of their grandchildren when I needed extra help. I also owe a big thank-you to Tom Perry and Carol Hunter for helping me become a better writer, for being a sounding board when I needed advice and for simply being there.

HEATHER TORPY

INTRODUCTION

The pages that lie ahead are my attempt to chronicle more than sixty years of broadcasting in the Midwest and a nearly equal number of years appearing at the great Iowa State Fair. This is not an easy task when you realize that, at this writing, I'm in my eighty-fifth year. So bear

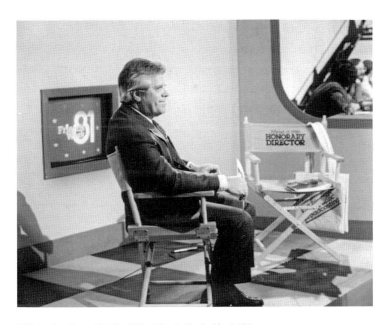

Bill during Iowa Public Television's *Festival* in 1981.

with me as I do my best to remember people and events stretching back as far as half a century.

It is said that when you get old, you forget what happened a few minutes ago, but as for what happened years and years ago, your memory is crystal clear. So relying on this, I'm going to share my stories with you. Why such an effort? Because I believe I qualify to encapsulate the years of early radio and the introduction of television. This is thanks to Iowa Public Television (IPTV), where I spent twenty fabulous years on *Festival*, with the IPTV broadcast signal extending even beyond the borders of the Hawkeye State, and to the *Bill Riley Talent Search* at the Iowa State Fair, which propelled me to conduct "hometown" talent shows in every corner of the state. I present my credentials in the hope that you will accept them and wander through these pages. It may be a bit disjointed at times, but it has one overall mission: to create a portrait of the past sixty-plus years in broadcasting and at the Iowa State Fair so that sometime down the road, those who follow might get a small taste of what early radio and TV were like. Thank you for joining me on this little trip down memory lane.

Part 1

BROADCASTING

1

Sixty Years
of Broadcasting

It was mid-October 1943, and I was out of the army due to a bad knee. It was time to face the real world again. The short association I had with the military was enjoyable, and as I left the service, my rank was second lieutenant, Military Police Corps.

But what prepared me for my future career in broadcasting came before the army. For four years, I was sports editor of the *Iowa Falls Times-Citizen*. That most wonderful episode in my life started in my junior year at Iowa Falls High School, when Carl Hamilton, later of Iowa State University fame, was just out of ISU and editor of the *Citizen*. He approached me one day while I was trying a new drink, Coke, with my mother at Aborn's Drug Store soda fountain in Iowa Falls. Carl introduced himself and said, "How would you like to be a sportswriter?" I was just sixteen years old and overwhelmed, but I certainly said, "Yes!"

My starting salary was one dollar per week and finally reached five dollars per week by the end of my years there. It was the greatest time of my life and really got my creative juices flowing. The last two years, while I was a student at Ellsworth Junior College, I even had a weekly column called "Sports Chatter by Bill Riley."

From there, I joined the U.S. Department of Agriculture in the information, or public relations, department. I wrote news releases and was thrilled when Jim Russell, farm editor of the *Des Moines Register and Tribune*, would run one of my stories in the *Sunday Des Moines Register*.

While with the Department of Agriculture in Des Moines, I was "loaned" to the Office of War Information (OWI) to do "counter propaganda short wave script writing." That assignment always looked good on my resume, and it was a wonderful experience. I would go to Pella or Orange City to find Dutch natives who would read a propaganda script that I had written about how great our country was. We would record it at a local radio station in the person's native tongue, and I would send the tape to the OWI in Washington, D.C. If it was acceptable, it would be aired on Radio Free Europe. Besides the Dutch scripts, I did some in German and Italian.

So with all this journalism and sports experience before and during my military experience and OWI work, I arrived in Des Moines in October 1943 and immediately started to look for a job. My first stop was WHO Radio, where Herb Plambeck had used some of my Department of Agriculture stories on his farm shows. Herb had always told me to look him up after the war, but when I stopped in to see Herb that morning, I found he was in some distant part of the world reporting on the war himself.

My next stop was the *Des Moines Register* to see farm editor Jim Russell. Jim didn't have anything at the time but said, "Why don't you go up to the twelfth floor and see the folks at the radio stations?"

That suggestion took me to the office of Chuck Logan, special events director for KRNT and KSO Radio stations. After a brief visit, Chuck said, "Come to work at 8:00 a.m. tomorrow."

I was thrilled to be hired, and at a salary of $37.50 per week, but there were so few able-bodied men available in 1943 that anyone who could write his own name could get a job. The excitement of radio and all it had to offer completely consumed me.

That's how it all started more than sixty years ago. My first job was as a news editor in the radio newsroom. The Register and Tribune Company owned KRNT and KSO and programmed them separately. Because it was wartime, we had a tremendous number of newscasts each day, plus commentaries.

Joe Ryan, Arnold Boomershine and I prepared leads for the newscasts and were constantly tearing copy from the teletype machines and trying to maintain some sense of order in the chaotic newsroom. With newsmen and announcers grabbing copy for newscasts on two stations, it was wild, to say the least. Between 1943 and 1946, we had news analysts, or commentators, just like we have on today's networks. But this was on local radio in Des Moines, Iowa. We had Stanley Dixon, John R. Irwin and George Saderneann, to name three. These men literally got into shoving matches to steal copy from the teletype machines for their daily commentaries. Those of us in the

newsroom had to be alert and fair with the dissemination of copy to these very aggressive and ambitious reporters.

It's impossible to name all the newsmen I worked with back then, but Glen Law does come to mind right away. Glen was a dominant name in local news during the mid-1940s. He personified the old-time, big basso–voiced newsmen. And he always ended his newscasts with, "That's the news according to Law." I remember bringing him the momentous bulletin that announced the invasion of Europe near the end of a dull election night in June.

During my three years in the newsroom, I started exploring the possibilities for expanding my career at the radio stations. These years of exploration took me from the sports department to personality shows like *Hey Bob*, *Party Line*, *Tune-O*, *Sunday Funnies*, the *Talent Search* and other endeavors.

My first on-air experiences were late at night, when the announcer on duty would let me read the sign-off, a five-minute newscast at 11:55 p.m. It was extremely exciting, and I loved being on the "air side."

A few of the early announcers who would let me read the news included Joe Penberthy, Dale Morgan, Bill Baldwin, Wayne Ackley, Gene Loeffler and Dan Lawrence. Ralph Powers, Jim Kelehan, Jim Lounsberry and other announcers came later.

After having the chance to read the late news, I found it was great fun to join the cast of *Sunday Funnies*. Anyone at the station who was available would get together and read the comic strips from newspapers, frame by frame, to young boys and girls who were listening. I even got the chance to read the funnies with Cloris Leachman and Bob Spake, two regulars who didn't work for the radio stations.

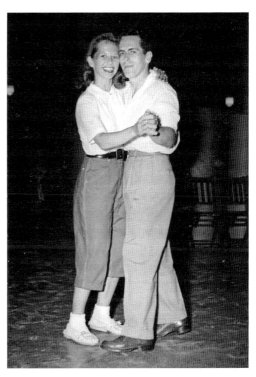

Anne and Bill dancing at the Riviera Ballroom in Des Moines.

Next came the coveted assignment as the announcer for the big band remote broadcast from Riverview Amusement Park on Saturday nights. It was an incredible feeling to stand before the great crowd of dancers, put my cupped hand to my ear and, in my best "announcer voice," say, "From the beautiful Riviera Ballroom, in Riverview Park in Des Moines, Iowa, it's Arnie Liddell, his trumpet and his orchestra." Those were pretty heady moments for a small-town Iowa boy.

As time went by, more on-air work came my way. My first actual show was when I hosted the *Football Scoreboard* after football broadcasts. I continued the show for the next twenty-five years. At one time, Herb Hein, a sports celebrity associated with a sponsor, Frankel's Clothing store, was on the show with me.

Once football season ended, I packed Saturdays with shows like *Calling All Kids*, *The Day Off Show*, *Buy and Sell* and *Auction of the Air*.

The idea for an auction show became quite successful and was even part of the Cowles Communication Annual report because of the revenue it

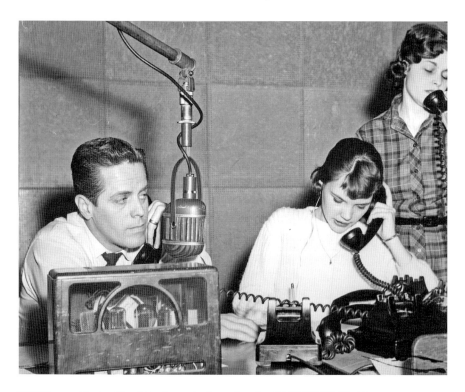

Bill Riley and Jenine Dewitt in the early days of radio. *KRNT/KCCI Television.*

generated. I conducted the auction for several years, and at one time the show was a full three hours, from 2:00 to 5:00 p.m., with eighteen sponsors. Each sponsor bought a ten-minute segment for roughly $150 (I received a $5 talent fee from each sponsor) and would provide an item to auction off, like a sewing machine. Our auctioneer, Walter Hayes, would "cry the sale," operators would take telephone bids and we would sell to the highest bidder at the end of the segment.

2

HEY BOB

The *Hey Bob* show was probably the most exciting time of my radio years. It was also the true start of a glorious lifetime of all sorts of programming that followed. I was twenty-six years old and full of energy. I became involved when Charles Mill, KRNT program director, came into the newsroom and asked me to come to his office and meet Bob Hassett, head of the Des Moines Safety Council and a police official from Omaha. He had an idea for a radio show. Bob poured his contagious enthusiasm into the *Hey Bob* project and was a key to its success. Two of the other people vital to the success of the *Hey Bob* show were *Hey Bob* policeman Tony Mihalovich and Charlie Triplett, who owned Triplett Toy Town. Tony was the police officer at Sixth and Grand who herded hundreds of youngsters across the street to the theater. Tony also appeared on the show at times. Although he benefited from the exposure, Charlie Triplett went far beyond the call of duty and provided thousands of dollars' worth of prizes for drawings that were held after the show each Saturday.

"Hey Bob" means "Hey, Be On the Beam," a slang phrase of the period. It meant be on the ball, be sharp, don't be a dummy. That was the whole program—don't be like Hey Bob, the dummy.

Indeed, we had a life-sized dummy. He was an affable Mortimer Snerd type and was a constant reminder to the boys and girls that they should not be like him but instead "be on the beam" when it came to obeying safety rules.

Right away, we set up a club. We added quiz features, safety skills, the financial fishbowl—a huge glass jar filled with pennies—plus all sorts of games like bubble gum blowing and balloon popping.

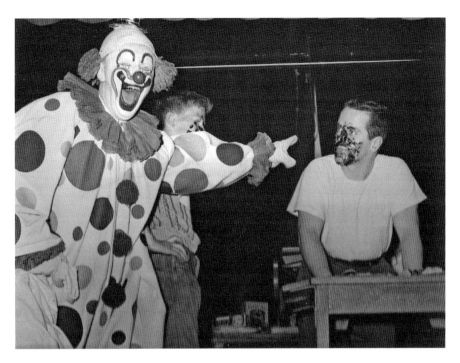

On the set of *Hey Bob* with Ko-Ko the Klown.

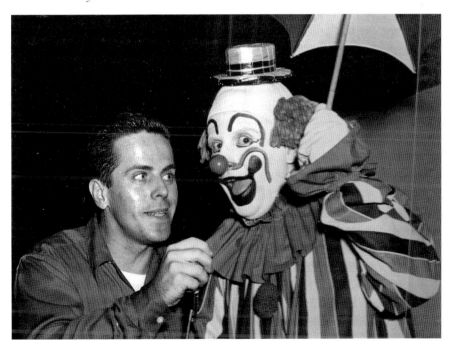

Bill and Ko-Ko did lots of clowning around on *Hey Bob*.

We also had the *Hey Bob* clown, Ko-Ko the Klown. Although we had more than one clown through the years, Guy Koenigsberger and his wife, Marvel, "Mrs. Ko-Ko," were the primary clowns during most of the *Hey Bob* years and were indispensable to the success of the show.

Although several announcers worked the show, Ralph Powers was the primary voice of the dummy Hey Bob. Hey Bob talked through an offstage microphone used by Powers.

The first *Hey Bob* show was presented in the early fall of 1946 and was held in the KRNT studio. We had promoted the show on KRNT, plus Mary Little used it in her radio talk column, *Air Glances*.

The first day of the show was a nightmare; there were so many children jammed into the studio that we could hardly move. The next week, we decided to move the show and do it remotely from our wonderful sponsor's business, the Utica Clothing Store in downtown Des Moines. That second Saturday was even worse. The new Utica was filled with hundreds of boys and girls.

Urgent action was needed, and the show was moved to the Paramount Theater in downtown Des Moines, where it was held for the next five years.

Each Saturday morning, we opened the doors at 8:30 a.m., had a warmup show at 9:00 a.m. and broadcast from 9:30 to 10:00 a.m. We had a drawing for prizes and had two cartoons on the big screen.

This was before TV, so it was a fabulous draw for children from all over central Iowa. However, the majority of the audience came from the heavily concentrated residential area to the north of downtown, where Veteran's Auditorium is now.

Literally, hundreds of boys and girls trooped downtown each Saturday. We always had more than one thousand fans come for each show and had to turn people away at times.

We did leave the Paramount Theater two or three times a year for specials from KRNT Theater, and this was done when we felt the crowds would be too much for the 1,800-seat Paramount. The KRNT Theater seated a little more than four thousand people. Shows there included "Holiday on Ice" and "June Dairy Carnival." And yes, we did the "Holiday on Ice" show on ice skates!

The 1948 "June Dairy Carnival" was the highlight of the series. We caused the city to call out emergency police to control the crowd. We had about five thousand in the theater (children sat two in a seat) and turned away another five thousand! The reason we have a fairly accurate number is because the dairies, including Anderson Erickson, Hiland, Flynn and Meadow Gold,

were cooperating with us to highlight June as dairy month. The dairies gave out five thousand cups of ice cream to the boys and girls streaming into the theater and then had to clean out the supplies around town to give each child who was turned away a cup—another five thousand!

That show was memorable, to say the least. It was so important that the Chevrolet director of General Motors sent a vice-president to view the show as a possible national network show for Chevrolet Division. It didn't fly, but we came so very, very close.

I also remember the day we gave a live pony away to a child. That afternoon, a phone call from a somewhat irate dad burned my ear. I can remember him asking, "Just what in *^%$ am I going to do with this horse standing in my backyard?"

We also tried something new one Thanksgiving. We decided to give away live turkeys and geese. All I can say is that the birds became nervous on stage, and the floor was covered with droppings. What a mess—and to top it off, the children left carrying big boxes with live birds inside as they got on the curb to go home. I hate to think about it!

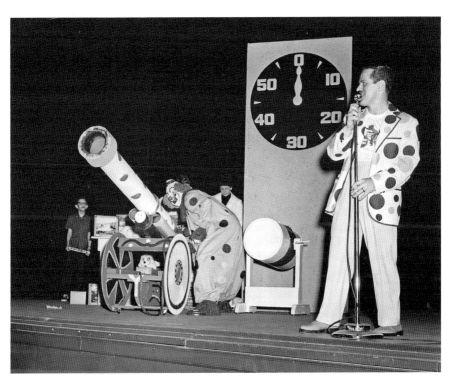

Fun on stage with Ko-Ko the Klown.

After the first two years, Colonial Bakers, the Wonder Bread Co., become the sole sponsor. Wonder Bread was great. Ko-Ko and Mrs. Ko-Ko had great Wonder Bread costumes, and I had my wonderful coat of many colors: my Wonder Bread Coat (which is in my attic).

Hey Bob lasted about six years, from 1946 to about 1953. The show had become too expensive to continue. Even the prizes had grown. During the first year, we gave away a bicycle. In the last year, we were giving away at least one per week.

3

QUIZ SHOWS

In the late 1940s, when *Hey Bob* was going strong, I received my second super assignment. I was named the KRNT Radio "Money Man." This was the first high-powered telephone quiz show in the Iowa market. It was so new and so untested that it used a complicated selection system. We called it "scientific selection." This was done to prepare ourselves for any governmental charge that we were conducting a game of chance under the lottery laws.

The concept hit the radio market like a bombshell. I placed the *Money Man* calls beginning at 12:30 p.m. as a feature of the *Don Bell Show* and each afternoon at 3:30 p.m., during the *Gene Emerald Show*. Starting with about five per day, the *Money Man* calls were soon expanded to nights and weekends.

I called numbers selected at random from area phone books. The calls were made live, starting with a ten-dollar prize and increasing by two dollars with each non-winning call. Jackpots usually ranged from thirty to forty dollars before there was a winner. I would read a commercial, and before the call I would remind the audience that "United Federal Savings," for example, was the answer I was looking for.

I would dial the first three numbers, calling them out on the air. Then I would say (and dial) the last two numbers. When someone answered, I would ask, "Is this Mrs. Jones?" or "Is this the Murphy residence?" If they answered yes, I would say, "This is Bill Riley, KRNT's 'Money Man.' Can you tell me the company I just talked about?"

If they identified the company, they had an opportunity to answer the Jackpot Question for the cash in the jackpot. If they missed, theater tickets

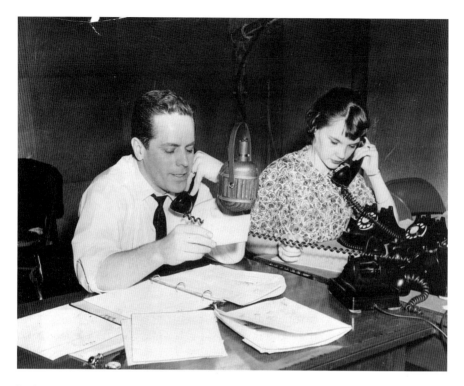

In the 1960s with Jenine Dewitt on *Party Line*.

would be sent as a consolation prize. The *Money Man* calls were made for at least three or four years, and with its success, other radio quiz shows followed.

Tune-O had an even greater impact than *Money Man* when it hit the airwaves. Sponsored by Hiland Dairy, it aired each weekday from 9:30 to 10:00 p.m. It was bingo, using music instead of numbers. *Tune-O* cards were available at all grocers selling Hiland Dairy products. New cards appeared every month.

At 9:30 p.m., I would start a game by playing just a few notes from a song, then another and another. When a listener heard "Deep Purple" and had "Deep Purple" on his *Tune-O* card, he would make a mark until he had bingo, or "Tune-O." I controlled the songs and had a master card, so I knew when a "Tune-O" was possible.

When that moment occurred, all hell broke loose. With thousands of cards in play, there were hundreds of possible winners. The phone activity was so intense that the phone company complained because suddenly, in a split second, we were overloading circuits. We also found as the weeks progressed that certain people were winning more than once. We finally

realized that very old dial phones (no push buttons back then) dialed faster than new ones and got to me faster.

Another problem was "advance dialing" by hundreds and hundreds of players. People would dial all but the last number. When "Tune-O" became possible, they all hit that last digit at once, and chaos reigned at the phone company!

Needless to say, *Tune-O* was a fabulous, entertaining show, but its technical problems kept it from lasting more than one season.

We also had a show, *Calling All Kids*, that used the thousands of names of *Hey Bob* club members. It was a simple format of calling members and asking Jackpot Questions. It was another enjoyable show for me because I loved the excitement of surprising youngsters with a call.

Relay Quiz was a good fifteen-minute show that aired each day at about 2:00 p.m. It was just like the *Money Man* with this variation: after I visited with someone, a winner or not, I would ask him or her whom I should call next—or "relay" the next call to.

It was really fun. A person would give a friend or relative's number for my relay call, but they could not warn them, since I would already be dialing the number. I heard stories of people running across yards, screaming at their neighbors to be ready for the *Relay Quiz* call.

Pick a Pocket was a delightful little radio show we presented on **KRNT** Radio on Saturday mornings. It was sponsored by the West Des Moines downtown merchants for about an hour each Saturday. It ran one fall for only about thirteen weeks in the early 1950s. One of the first of my many wonderful young college assistants, Karen Long, would go with me to downtown West Des Moines, and we would visit the various sponsors' business locations. I wore my *Pick a Pocket* apron with several pockets, each filled with a special gift. I would stop a shopper and ask the person if she or he would like to "Pick My Pocket." After a brief visit, that person would answer a simple question, choose a pocket and get a prize.

The quiz shows were a most enjoyable part of my early years in radio. I loved my job so much that I could hardly wait to go to work, and that excitement continued for twenty more years at KRNT Radio and Television.

4

SPORTS AND PUBLIC ADDRESS

As a result of my four years as sports editor of the *Iowa Falls Times-Citizen*, I quickly gravitated toward doing sports and public address announcing. My first sports announcing job was on radio station KFJB in Marshalltown. Jim Lounsberry, one of the KRNT Radio announcers, and I would take the train from Des Moines to Marshalltown each Friday afternoon during the 1945 basketball season. We would arrive in Marshalltown about 4:00 p.m. and would pick up the broadcast equipment at the station. Then we would drive to the game site and broadcast the game live. Jim would do most of the play-by-play, and I would do color commentary. I felt like Ronald "Dutch" Reagan (former U.S. president, actor and WHO Radio announcer), actually broadcasting sports. It was an inspiring job.

After the game, we would pack the gear and drive back to the studio. Sometimes it was close, time-wise, as we rushed to catch the late train to Des Moines. By the time we got back to Des Moines, it was nearly dawn, but it was worth it. The experience was tremendous.

Always volunteering, I soon was doing color sports commentary for KRNT and KSO. I started out working with one of the best announcers of them all, Gene Shumate. He was from the "Dutch" Reagan school of sports announcing, truly excellent. I was not the first assistant sports man to turn the mic back to "June Shumate." Gene told me everyone he ever worked with had fumbled with his name at one time or another.

After Gene came Jon Hackett. Jon was flamboyant. He was an exceptionally exciting announcer, especially for basketball. Once, at a state tournament in

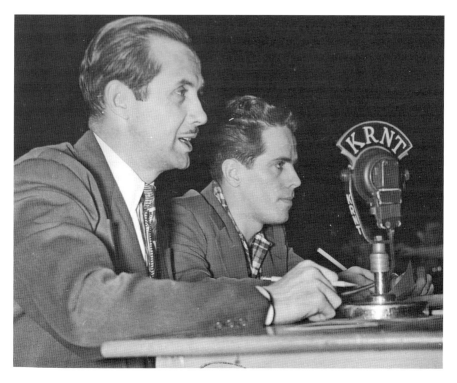

Jon Hackett and Bill Riley doing sports announcing.

Iowa City, he became so animated that he fell off his chair. Jon was dynamite and went on to a career in California.

Once, Jon and I were coming home on the Rock Island rocket train on a Sunday afternoon after broadcasting a Saturday football game. We were in the club car, and I began visiting with a wonderful older gentleman. He was very interested in radio and seemed impressed with the fact that I was a sports announcer. I talked my head off, and he listened. When we arrived in Davenport, the gentleman got up to leave, stuck out his hand and thanked me for telling him all about radio. His name: Colonel B.J. Palmer, Iowa's radio pioneer. I wished I could have crawled under the train, but then I realized that he truly enjoyed hearing about the constant excitement I was experiencing in my radio job.

Then came Al Coupee, the Iowa grad fresh from the Washington Redskins and 235 pounds of muscle. I was the first to take "Coop" out for a test run. We went to a Drake football game with our "wire pick a pocket recorder" and simulated an actual broadcast, with Coop doing the play-by-play and me doing the color. I remember reporting back to Chuck Miller,

our program director, and telling him Coop would never make it as a sports announcer. How wrong that analysis proved to be, as Coop went on to become one of Iowa's most popular announcers and, later, number one in Southern California.

This period of sports announcing during the mid-1940s was so much fun that I could hardly wait for each weekend to arrive. Iowa versus UCLA from the Coliseum in California, the Big Ten football games, Notre Dame, Drake basketball, Iowa State sports and the Drake Relays.

The sports announcing automatically led me to sports public address work. I have always loved PA work, and I took advantage of any offer that came my way.

In about 1946, I was doing the Iowa Bruins baseball games and the auto races on the track set up by Marion Robinson on East Fourteenth Street in Des Moines. I remember doing the PA on the races from the cab of a truck with a tiny little microphone. Robinson went on to help develop the highly successful Knoxville racing program. Doing the Bruins and auto races, plus my busy schedule at the radio station, posed problems when events would conflict. Someone suggested a new young sports announcer at WHO Radio who might want to cover for me when I had a conflict. He took over the extra racing jobs and developed his auto racing skills in PA over many years. His name was Jim Zabel, and we have remained good friends through more than four decades.

The girls' state basketball tournament was one of my PA favorites. I was the tournament announcer over a span of eleven years in the 1950s, and it was the first major event in Veteran's Auditorium. I think the crowd for the championship might have been one of the largest ever to jam into Vet's. I remember all the aisles were filled. It must have been a fire marshal's nightmare.

I was always working more than one job, and I became sports publicity director for the Iowa Girls Athletic Union under Red Chisholm. We had a great time setting up the first girls' basketball weekly ratings, conducting the state free throw tourney and doing special promotions during the state tournaments.

I remember between games at one state tourney I pitted Red Murrell, a Drake great, against Mary Armstrong, a Wiota star. They took set shots and, I believe, some free throws, and you guessed it, Mary beat the fabulous Red Head.

By the way, Red Murrell was the first Drake basketball player to score fifty points in one game. It was at the old Drake Field House, and it was a shot fired from just left of the free throw circle to register his fiftieth point. Of

course, Drake basketball was my great love for thirty-seven years. It started in about 1945 and lasted into the 1980s. I remember Bill Evans, one of Drake's superstars, and how he could clean that defensive board and bring the ball down the floor.

When Hank Iba brought his vaunted Oklahoma A&M teams to meet Drake, Bob Kurland was the first mean seven-foot "giant" of those years. I loved all those Drake basketball memories, introducing the phenomenal freshman from Indiana State named Larry Bird and Cincinnati's Big "O," Oscar Robertson, and all the Drake stars.

Drake football was hard work. I had to walk up and down the sideline with mic in hand, following the play. But I worked Drake PA when Johnny Bright was one of the nation's greatest players. What a thrill it was to be so close to the action.

After one Drake football game, a gentleman named Don Ault complimented me on my work and asked me if I would consider doing the PA at the Drake Relays. I nearly fainted, for two reasons: the Drake Relays was a national event, and I didn't know anything about track and field.

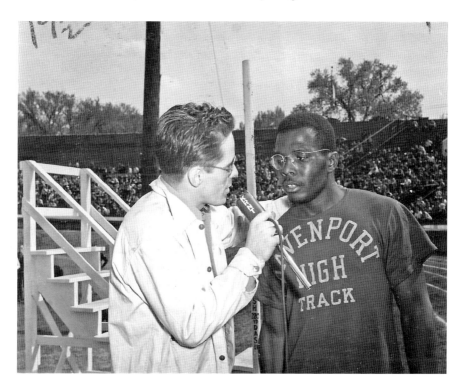

Bill covering the Drake Relays.

Don assured me the latter would be no problem, as he would have a gentleman at my side literally spouting information into my ear. Don said he wanted to bring excitement to the Relays' PA. So that's what we did for the next three years, screaming to the crowds to "bring them in" as a race neared the finish line.

The man who spouted information into my ear constantly and made me sound like a pro was Jim Duncan, who finally took over the PA himself and for whom the Drake Stadium track is named. Jim Duncan was a friend all through the years. He had a truly incredible intellect and a photographic memory, and I always will consider it an honor to have known him.

It's tough to grow old and give up the things you love. Doing the PA for most everything in central Iowa at one time was so personally and professionally rewarding and just plain fun. I'm still very proud to have been called the "Voice of Drake Basketball."

TELEVISION'S IOWA DEBUT

Although a technical exhibit of television was featured at the 1942 fair, in 1946 there was a communications milestone in Iowa, and it was a complete presentation of television programming as it would exist from then on (as mentioned in our *On Stage* book, highlighting the forty-five years of the talent show through the 2004 state fair). The 1946 production used the entire giant International Harvester tent for the stage and TV sets to be viewed by the visitors—about a third of a million! We had a big stage at the west end of the building and then had television sets placed throughout the big tent.

What a thrill for me to walk on stage and explain the electronic miracle and to invite those jammed in the tent to watch the TV sets and see the stage presentation live. I loved programming in those days. How easy it was. Everyone wanted to be on television. Unfortunately, the weather for that portion of the 1946 state fair was really miserable. It seemed like it rained almost all the time, though in truth it did not, because we did several afternoon shows remote, outside the tent, where I did an interview segment with fairgoers.

Bob Cannon, whose father was a KRNT engineer, has supplied us with pictures of what is believed to be Iowa's first exposure to television. Bob Cannon was a teenager at the time and worked as one of the cameramen.

Bob has also provided us with his memories of what happened during the 1946 Iowa State Fair.

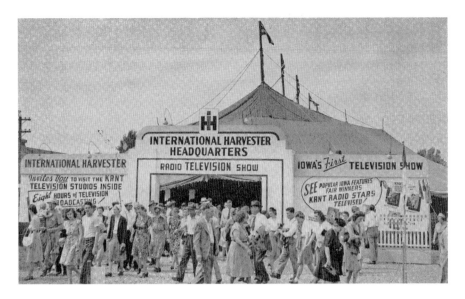

The International Harvester tent in 1946.

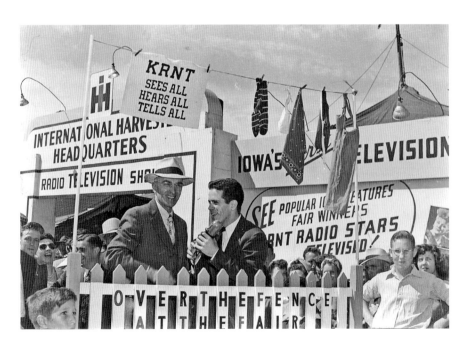

Over the Fence at the Iowa State Fair. *Bob Cannon.*

1946 IOWA STATE FAIR

Bob Cannon

The year 1946 is one that will be remembered by me as the beginning of the rest of my life. After being discharged from the U.S. Navy in May, I had some time on my hands to decide what I was going to do. One day, I got a call from my dad's boss, Charlie Quentin, and he wanted to know if I would be interested in operating a TV camera at the Iowa State Fair in August. And I said, "Just what is TV?" He explained that it was like any camera, only it makes an image on an electronic screen. Since photography was always a hobby for me, I said, "Sure, fine." Then he asked me if I knew anyone else who might be interested. I thought for a moment, and I said, "Maybe one of my classmates might be. His name is John den Boer." I gave him a call, and he said yes. That day was the beginning of [the most] wonderful and exciting experience that anyone would ever have in their lifetime.

The Iowa State Fair didn't have a very dry beginning when it did start. There were rain showers, I think, for the first two or three days. We were located inside a huge International Harvester tent. It wasn't the best situation for electronic equipment, with water seeping in all over the place. Of course, we tried to keep the equipment covered when we could, but as they always say, "the show must go on." Not only did we cover the camera and audio equipment, [but] there was all of the lighting gear on stage. The lighting equipment was on tall stands, with fourteen reflector lamps on each. Each lamp was five hundred watts and had a life expectancy of only six hours. The lighting stands were called Eddy-Banks, and there were three of these used on stage during a show. Many lamps had to be replaced after a few shows because of their short lifespan. Of course, the daytime temperatures in August were rather warm, so the heat generated by the lights made it even hotter on stage. The Eddy-Banks were alternated between the two cameras: Eddy-Bank, camera, Eddy-Bank, camera, Eddy-Bank. With all of the wattage, there was plenty of light to help make an image for the camera. The image was passed through the lens onto the pick-up tube, which was called an iconoscope. This was transformed into an electronic image, the same as it would be in a film camera. It took a lot of light for these cameras. Years later, a tube was developed, called an image orthicon, that required less light to produce a TV image.

Since there were no live TV stations on the air in Iowa at the time, the television image was on closed-circuit cable to various monitors around the inside of the tent and outside to show the passing public.

The cameras, as well as the cameramen, were on plywood platforms with wheels so that they could be moved about on stage. The cameramen wore headsets to listen to the director's instructions for what they should do. Then, the cameraman would use hand signals to instruct a Boy Scout to move the platform around the stage. There were no viewfinders on the cameras and no focus controls. The cameramen just had to listen to the director about which way to aim the camera. Then, a camera technician in the control room would control the focus of each of the cameras.

In the short time at the fair working with television, I knew what I wanted to do as a working vocation: television. I like to refer to it as being bitten. I am totally glad that I did make that my decision.

People began to ask me how long before live television would be in Iowa. At the time, they thought it would be just a few years. Well, then there were some problems with getting construction permits. The FCC had it tied up for a number of years before they would issue any permits. KRNT finally got its permit, which was about eight or nine years later. I kept knocking on the chief engineer's door, off and on, all of this time. In the meantime, I had to make a living.

My parents wanted me to continue my education by attending college. I agreed, and I enrolled at Drake University. I had some college credits from my time in the navy, since I was training to be a pilot. I took journalism as my major.

Photography was a hobby in my younger years, so I became a photographer for the college paper, the *Drake Times Delphic*. One day, I met a professional photographer who had a contract to photograph the students for the annual college publication. I wasn't very happy in college; it just wasn't what I wanted to do. I made a job application to work at his studio and later started working for him on the GI Bill on-the-job training. As time passed, I worked at a couple of portrait studios and as an assistant manager at a local camera store. Then one day, I got a call for which I had been waiting for nine years. It was the chief engineer for KRNT, and he wanted to know if I still wanted to work for them. I said yes! I made a job application and got the job. I began on July 24, 1955. I worked sign-on camera on July 31, 1955. That was a very big thrill for me. I worked at KRNT/KCCI-TV for thirty-five years. I retired from there on July 28, 1990.

6

BROADCAST BEGINNINGS

Let me take you back to my first days with KRNT-TV in July 1955. We had rehearsed in the basement of the cavernous, old KRNT Theater for several months, so we were all ready for the career opportunity of a lifetime that afternoon in July. During the early days we were on the air, people did breaks between shows. We had about thirty seconds during the break to welcome all our new viewers and then call for the next show.

We went live, and I remember calling for the *Lone Ranger*. The only problem was the *Lone Ranger* did not come on the air. The studio directors signaled me to stretch, so I kept yapping away for what seemed like an eternity. In a couple of minutes, they signaled that the *Lone Ranger* was ready to be shown, and I—sweating like a weight lifter—was off the hook. Although people congratulated me on filling those two minutes, I had absolutely no idea what I had actually said. I just kept talking, and I guess I've been talking ever since.

Right away, Mary Jane Chinn Odell and I started *What's New*, a half-hour program each weekday at 11:00 a.m. Mary Jane was a delight and a genuine professional. Our first week on the air, we gave away a small TV set as a grand prize for those who sent in a postcard for the drawing. We received more than fifteen thousand postcards in one week, which gave us a good indication of the power and potential impact of television.

Apparently, management was happy with the way Mary Jane and I adapted to TV. As a result, we both got our own shows. Mary Jane kept the 11:00 a.m. spot, and I took over the *Noon Show*, from noon to 1:00 p.m. every weekday. The show was my pride and joy.

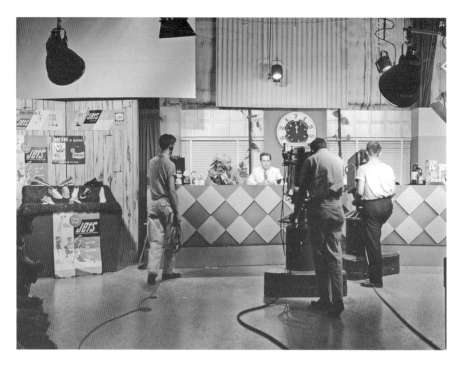

The *Noon Show* on KRNT-TV. *KRNT/KCCI Television.*

Don Soliday handled the news segment of the *Noon Show*. We had cartoons for the boys and girls who were home for lunch. That was back when not everyone ate at school. We had interviews, the "Shadow Stumpers Quiz" and animals from the Rescue League with "Holly" Hollingsworth, and we were always involved in promoting civic projects, like the collection of thousands of buttons and neckties for Goodwill Industries, the Christmas Seals campaign and other similar projects.

One of the most exciting and dramatic broadcasts of the *Noon Show* was one summer day around 1960, when at about 12:30 p.m. Dick Covey, our program director, told me during a break that "some guy is buzzing Des Moines in a small airplane." Dick told me to start reporting what was happening as he had the engineers move a camera up to the roof of our studio at Ninth and Pleasant Streets downtown.

When the camera was in place, we cut to the roof camera to catch this guy as he would circle the state capitol dome and then head straight for our TV tower. Then he would suddenly circle and go back to the capitol.

In those days, there was little air conditioning, so the telephone company building next to KRNT had windows open on all the floors. The renegade

airplane pilot would actually fly his plane as low as about the third floor of the building, and you could hear the phone company employees screaming, as the plane seemed only inches away.

I stayed on the air from noon until about 3:40 p.m. that afternoon, when the plane landed in West Des Moines. We learned that the pilot was upset because he had not passed his flight tests and chose this frightening way to prove he could indeed pilot a plane very well. It was a memorable day for me, with three hours and forty minutes of live, on-the-air reporting. It showed how television would change our world and the way we cover it.

Not every *Noon Show* offered high drama. Sometimes it offered comic relief instead. Once, a pet raccoon decided to sit on my head. Then there was an incredibly expensive show cat that bolted from the set and ended up in the lighting grid overhead.

Another time, a cat I was holding panicked and stuck its claws in my hand, which resulted in serious blood loss. What would you do with an elephant that became restless while on camera or a python that got too friendly around your neck? I sometimes had to think mighty fast. Wonderful Bob Elgin from the Des Moines Zoo once showed our viewers an almost full-grown tiger cub on one *Noon Show* that suddenly decided to give me a big hug. It was live TV at its best.

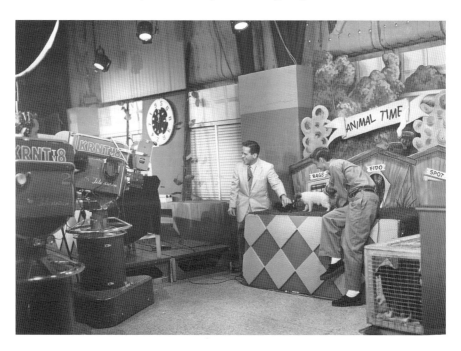

Bill Riley during "Animal Time." *KRNT/KCCI Television.*

We have the Animal Rescue League and Bob Elgin from the zoo to thank for all the animal appearances on the *Noon Show*. Oren Herndon of Des Moines Seed and Nursery is also to thank for keeping the TV station supplied with parrots and myna birds. One myna bird was always great in his cage on the big set of the *Noon Show*. He would talk, and he had an evil laugh that could come at any moment. During one memorable show, the laugh was heard during my interview with movie star Ronald "Dutch" Reagan.

7

TELEVISION SHOWS
ON KRNT/KCCI

I was so very lucky to have Bob Dillon, a really magnificent human being who was one of my biggest boosters, as my station manager. With Paul Elliott in charge of sales and Joe Hudgens and Dick Covey as program directors all helping me with my many projects, I couldn't help but succeed.

With the station's support, we quickly created TV shows to fill the programming void. Remember, every minute was live; there was no videotape in the 1950s. We had network programming, but only during certain hours.

Preparing for another big show. *KRNT/KCCI Television.*

TEEN TIME AND TALENT SPROUT

We created *Teen Time* from radio and a spin off with the *Talent Sprout* show. *Teen Time* was each Sunday afternoon at 2:00 p.m. and, of course, was live! We had singers forget words, piano players freeze, dancers slip—it was true, wonderful, old-fashioned television!

We never had trouble filling the show each week. I think we had four senior acts and one sprout who performed during judging. One winner each week came back for the championship show on the fourth week. Then the whole concept was repeated for the next four weeks.

We held auditions each Tuesday night and soon started visiting schools with local competitions, with the winners coming to the TV shows. Thousands and thousands of dollars were raised for PTAs, band projects and similar school organizations. I was soon doing sixty auditions each school year. As always, we had dedicated people helping us—judges like Ralph Zarnow, Jim Duncan, Bill Henderson and many more too numerous to mention. The tradition continues to this day at the state fair, where judges add credibility to the *Talent Search*.

VARIETY THEATER

Variety Theater was the name of the afternoon boys and girls' show. It ran from 4:00 to 5:00 p.m. each weekday afternoon. It started in the 1950s and was a popular feature for some twenty years.

Bluebirds, Brownies and Cub Scouts visited the show each day. We were booked for months ahead of time. The groups came in after school and then were treated to being on the set and visiting live on camera. The visiting group was introduced individually and told me facts about themselves. These visits would occur between segments of the film being presented.

One of our first and most popular features was the "Little Rascals," the original *Our Gang* film. What fun it was to show Farina and all the Rascals to a new generation of young folks. During the course of *Variety Theater*, we featured many different films, including *Sergeant Preston and King* and

Opposite, top: Variety Theater.

Opposite, bottom: Interviewing the Girl Scouts on set.

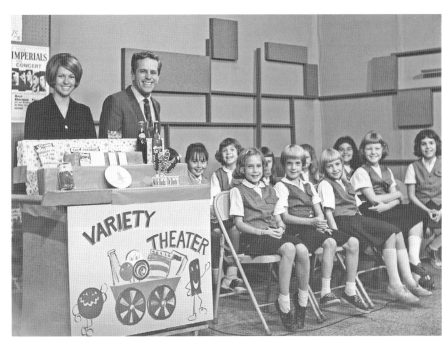

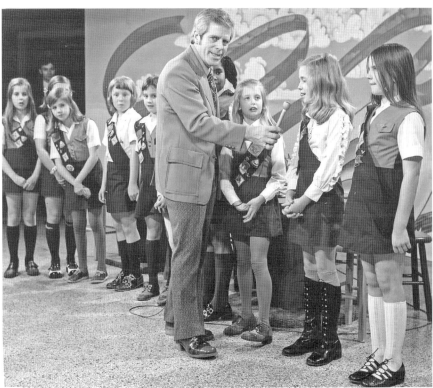

Art Linkletter and Bill Riley.

adventure serials like *Death Ray Destruction*. I remember watching those at the Met and Tex Theaters in Iowa Falls as I was growing up.

Between the live portions of the show, we would seat the youngsters at a big table and provide them with treats—usually ice cream in cups, Twinkies, Jacobson's Cupcake candy bars, just all sorts of the worst possible things to stuff into youngsters, but it was enjoyed by all.

We had a very special visitor for *Variety Theater* one afternoon. It was Art Linkletter! He was in town promoting something, so we scheduled him in for the show. He was so very nice with the children and handled the interviews for me. This was a thrill for our young visitors, as Mr. Linkletter was a big name at the time. But here is the interesting part of his visit to our set. After the children were gone and we were saying our goodbyes, Art told me that in the past few months a man had come to him with an idea, but he needed funding for the project. When asked how much, the man said all he needed was $10,000 to buy lots and lots of garden hose. Art said that was "chicken feed" when it comes to starting an enterprise. So he advanced him the money. Art said the garden hose probably hadn't reached Iowa yet and

asked if I had ever heard of the hula hoop. He said, "Bill, when you get a chance to help a person with a wild idea, do it! It may be another hula hoop." Just think of how many times over that investment was returned to Mr. Art Linkletter!

Of course, there was lots of competition for the late afternoon viewers. It started out with Slim Hayes, who had the young folks segment on WHO-TV, Channel 13. Slim was the perfect cowboy. He and I were good friends and enjoyed knowing each other.

I remember being with Anne and the family in California in the late 1950s. We had just entered Disneyland right by the little train when who should we bump into but Slim Hayes and his wife. They used to sing on the Disneyland ride "It's a Small World."

Following Slim Hayes on WHO was Duane Ellett of *The Floppy Show* fame. Again, we were good friends, and neither of us was much concerned about being competitors.

THE *BREAKFAST CLUB*

The *Breakfast Club* was probably the most popular of the children's shows. I suppose it was about 1960 when Joe Hudgens, our Channel 8 program director, called me in and hit me with a bombshell offer: a boys and girls' program on TV every morning, Monday through Friday, from 7:30 to 8:00 a.m., right before *Captain Kangaroo*. What a spot!

I was incredibly busy at the time with all the radio shows and also with the *Noon Show*, *Variety Theater* and a batch of weekend shows. Besides television and radio, I also had outside jobs. I was publicity director for the Iowa High School Girls Athletic Union, and I was Iowa Senate reporter for United Press International. These jobs, plus public address work every night, just about had me buffaloed (with a big family, I had to work several jobs).

Even with all those other responsibilities, I don't think I even hesitated in responding to Hudgens's offer. The first thing we did was to set up the *Breakfast Club* with a big spinning wheel for prizes. It turned out to be a fabulous success. We had shipments each fall from Tonka Toys and a host of other companies that all wanted that free TV exposure. We loved the mountain of prizes we awarded each week on the *Breakfast Club* and *Variety Theater*. We also had cases of Archway Cookies and hundreds of boxes of Jacobson's Cupcake candy bars (made in Des Moines). Milton Ohringer was

Breakfast Club membership cards.

a good friend of mine and president of Jacobson Candy Company. We had Bun candy bars as a sponsor, and as a result, I received cases each month for the studio visitors and for awards. As the TV lights made the studio warm, we had a special box of Bun bars that I would hold as I delivered the commercials on *Variety Theater*.

One day, there was crisis; the prop box of Bun bars was gone, stolen by some very hungry person who had made his way into the property room. Can't you just envision that stealthy, Bun bar–starved thief creeping into the prop room and sneaking that full box of bars out of the station? And can't you picture the surprise on the face of that hungry thief as he opened the box, grabbed a luscious Bun bar, tore off the colorful wrapper and found the results of his carefully planned heist: a box of beautifully wrapped wooden blocks in the shape of Bun bars.

Over the years, the morning club brought in about twenty-five thousand club members and was a big hit. Just like the afternoon show, I geared the morning club to films, prizes on the spinning wheel and live segments. We had our own "Mr. Morning Newsman," Bill Johnson. I know the *Breakfast Club* resonated with the audience because even today, when people reminisce about the good old days, they inevitably mention the *Breakfast Club* instead of *Variety Theater*.

In later years, with the advent of the videotape, we started to tape segments during *Variety Theater* each afternoon for the next morning's show. Then the *Breakfast Club* became a breeze, and what a great vehicle it was for promoting all of our pet projects. Those twenty-five thousand boys and girls spread out across the heart of Iowa would respond with enthusiasm every time we launched a project, whether it be collecting neckties, building the zoo or constructing bike trails.

Yes, the *Breakfast Club* will always be a shining star from my years at Channel 8.

ZOO SHOW

Another delightful little television show was the *Zoo Show* on Saturday at about noon on Channel 8. It was an outgrowth of our previous efforts to build the zoo and the fact that we had zoo director Bob Elgin on other shows as a guest. It was just automatic for Bob and his friends to have their own show.

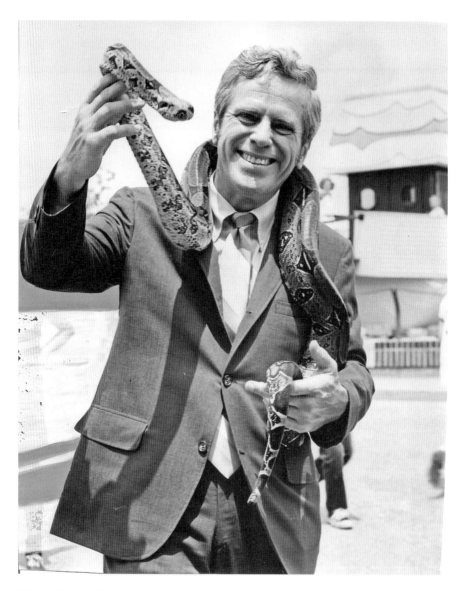

What a big snake!

Bob would arrive each Saturday and would always have a surprise guest, like a huge snake. One day I will never forget is when he brought in a "baby" tiger that was about the size of a full-grown Great Dane dog. I remember that Bob assured me that the beast was very tranquil, but I didn't like the way the tiger was sizing me up. Although on a leash, the tiger suddenly lunged at me with his paws on both my shoulders and his face only inches

from mine (talk about dog breath—you should sample tiger breath!). I about lost it. I still can remember feeling those huge claws through my coat and against my skin. Bob Elgin quickly restrained him.

Our daughter Peggy worked at the zoo during her school years and would come in once in a while with Bob. One day, Peggy had a huge boa constrictor draped around her shoulders. I knew the snake wasn't poisonous, but during that show, Bob removed the snake. During a commercial, I asked why, and Bob calmly informed me that the snake was "hissing" and he might strike. If he hit Peggy, his fangs could leave a deep gash. I was a bit unnerved, to say the least, as I certainly didn't want my beautiful daughter injured.

After the show, the snake became docile again, and I hoisted him on my shoulders and took him all around the TV station business offices. Boy, if that didn't shake things up a bit!

BRUCIE TIGER

Bob Elgin

Brucie, our big Bengal tiger, was one of the fifty very big cats that we adaption trained during the sixteen years I was director of the Des Moines Children's Zoo. Adaption training was a very effective and humane way of caring for the zoo's large predator animals. It created a deep and lasting bond and friendship between the trainer and the animal.

Many of the cages in the exhibit area were quite small, and the adaption-trained big cats, wolves and elephants were much happier and much more at ease in their proximity to the zoo's human visitors.

This motivational training technique that I borrowed from training falcons also permitted the zoo staff to move animals from one place to another by simply placing a collar around their necks, attaching a leash and permitting them to jump into a transport crate or my car.

It also allowed us to take the big cats many places that lions, tigers, leopards and jaguars don't normally go. We took several of them to St. Louis, Chicago and Canada. Jackie Jaguar made several appearances (along with a cobra and a big python) on the *Regis Philbin Show*. We once took a big lioness (as well as one of our trained eagles) to a TV show in Chicago.

The animals seemed to love the excitement of travel and appearing before the TV cameras. With the exception of the cobra on one of the *Regis Philbin*

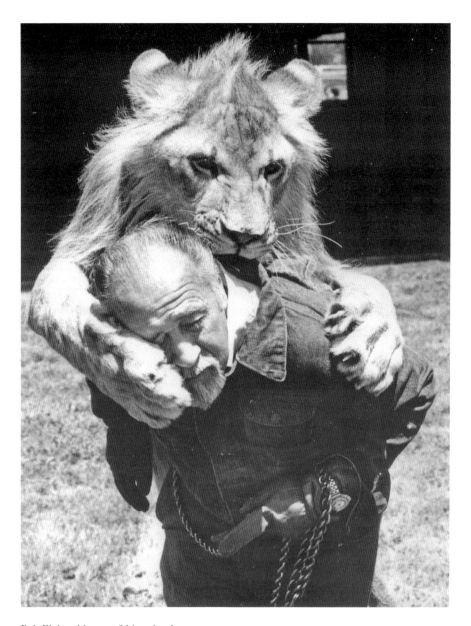

Bob Elgin with one of his animals.

shows, I can say with great pride that they all behaved with dignity and displayed excellent manners.

Brucie Tiger, however, didn't make any of these distant trips. He did make an appearance on our local weekly TV show, though. It was an unforgettable

experience for Brucie Tiger—for Brucie Tiger found a true friend in Bill Riley. Bill was the zoo show host, and Brucie Tiger made an instant decision. To show his liking for his new friend, he jumped up and placed his big paws on Bill's shoulders. This rather surprised Bill. All Brucie wished to do was to express his affection, but Bill was understandably frightened. I pulled back on the leash, and Brucie instantly sat down on the floor. Then Brucie just sat there, smiling all the while, making his soft "pffft" sound, which means "we're friends." Bill took a deep breath and went on with the show.

I had faith in Brucie. I knew he would behave himself. For the sixteen years I was at the zoo, our big cats and the other animals we adaption trained never disappointed me or injured me in any way.

Their training and their obvious adaption to our strange human ways even took a humorous turn on several occasions. One day, for instance, five very intoxicated men entered the zoo and proceeded to make the rounds from cage to cage, teasing and frightening every animal. When they arrived at Brucie's cage, they were behaving in a manner that would have shamed the whole human race. The zoo's foreman, Earl Connet, hurried to my office and proceeded to tell me of the difficulties he was having with the drunken visitors. There wasn't anything he could do to stop them, he explained. Did I wish to call the police? Or did I have some other solution to the problem? I told him I probably did have another solution. I grabbed Brucie Tiger's leash and headed for his cage. The idiots were still there, jumping up and down, behaving as though they were completely berserk.

They stopped this behavior when I appeared with leash in hand. I explained to them that if they really wanted to tease Brucie Tiger, I would be happy to take him out of his cage and allow them to continue their antics a bit closer to the big cat. This provoked a roar of laughter from the five men. You can't go in there, they told me. That tiger is mad, look at him. He'll eat you alive! I opened the door to Brucie's cage. He was happy to see me. I placed his big collar around his neck and attached the leash. Brucie pulled me out of the cage. The men suddenly became very quiet. They looked at one another. One of them said in a voice slightly above a whisper, "Let's leave, right now."

They left, walking rapidly toward the zoo's exit. Brucie and I followed them, just ten steps behind. They walked the long distance from the tiger's cage to the exit and left. They didn't bother to ask for their money back.

Vandalism was a constant problem at the zoo. For fifteen years, however, the zoo's budget would not permit me to have a night security man. On one occasion, after some animals had been killed and our cougar had been

released from his cage, I made the comment to some of the zoo staff that perhaps we should use Brucie Tiger as a watch cat. Somehow or other my statement leaked out to the news.

One night, the TV crews set up numerous cameras, turned on a multitude of lights and waited for me to enter Brucie's cage and emerge with the tiger. It was most humiliating. Brucie was bewildered by all the lights and proceeded to pull me off my feet. This delighted Brucie. He pounced on me, rolled me around like a big ball and then just laid down on me. I had a terrible time extracting myself, as usual, from beneath his big body. The whole thing was most undignified.

While the TV people screamed with laughter, I managed to get Brucie under control and lead him around the area so the TV cameramen could get the pictures they deserved.

While I considered the whole affair, at least my part in it, as pretty ridiculous, the idea seemed to catch on. *Captain Kangaroo* even showed the watch cat on his children's show no fewer than five times. Other TV shows and newspapers picked up the story, and to my consternation, it went around the world. The Des Moines Children's Zoo had a tiger watch cat, whether I liked the idea or not.

Brucie and I did patrol the zoo at night on many occasions after that. Then, when I did go down to the zoo at night to check to see if everything was safe (often it was not), I would just sneak into Brucie's cage and stay with him. I felt much safer there. Some of the vandals had even been indicted of murder. I certainly did not wish to confront them, and I knew Brucie would protect me.

Brucie's watch cat story had a rather strange ending. In the 2004 issue of *Ripley's Believe It or Not!* there is a picture of Brucie and an old man (me) sitting in front of the zoo's exit gate. Above is a sign saying TRESPASSERS WILL BE EATEN!

BATTLE OF THE BANDS

This show was of short duration, probably in the 1970s, and was a wild idea of mine to showcase the rock bands that were so popular at the time. I'm sure I was influenced by my son, Eddy, who was in a "group" from eighth grade through his mid-college years, with the final group called the Wichita Flash. They even played the big spots like the Surf Ballroom in

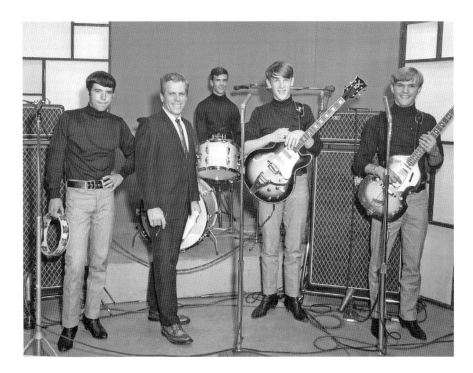

Rock bands were showcased in the 1970s.

Clear Lake. The whole idea of "battle" was to have two groups each week on the television show. Each would play for fifteen minutes. After that was when it got to be interesting because there were no judges. I asked viewers to send in postcard votes for their favorite band (postcards were only one penny each). Although the show ran for only one season, it was a roaring success. The postcards arrived each week by the carload! It turned out that groups who were very popular urged their followers to flood the ballot box with postcards. I honestly was amazed. I think this was another time that I really experienced the incredible power of the new medium television. This show was the impetus for the *Battle of the Bands* at the Iowa State Fair in Teen Town. The *Battle of the Bands* television show and the later events at the fair also led to a great honor for me: being inducted into the Iowa Rock and Roll Hall of Fame in 2004. What a great organization; it has a wonderful website full of Iowa music history.

8

SPECIAL PROJECTS
AND PROMOTIONS

I have always enjoyed rallying people to join in some sort of a campaign, whether it be collecting buttons for Goodwill Industries or riding our bikes to build bike trails. There has been a bundle of promotions through these sixty years. With the advent of television, plus the tremendous exposure on so many different shows, I found myself almost always involved in some specific project. Here are a few of them.

BUTTONS FOR GOODWILL INDUSTRIES

I talked about the *Noon Show* earlier, but one of my first attempts at asking viewers to help in a specific drive or project came from an interview with Goodwill Industries one day. During the interview, the Goodwill representative mentioned how much Goodwill needed everything—even buttons. Well, the idea was born right there on the show. I asked our viewers to respond by sending or bringing in buttons—all kinds of buttons, any buttons. I'm not sure anyone with any degree of sanity would have suggested such a project, but I blurted it out and then waited. I didn't wait for long because buttons literally came rolling in; not hundreds but thousands of buttons from all over central Iowa.

NECKTIE ROUNDUP

Also on the *Noon Show*, I collected neckties for Goodwill Industries. The same thing happened. I appealed to viewers to clean out their closets and send me neckties. They came in by the boxful. Someone in our promotion department actually counted them, and we had more than twelve thousand stylish cravats. Can't you just picture some housewife going into her husband's closet and taking a whole armload of his neckties? Or some sweet little Brownie appealing to her dad to "help Bill collect ties?" And indeed, the boys and girls helped, as they did on all drives, because I would pitch drives on all shows, from the *Breakfast Club* through the *Noon Show* and on *Party Line* and, in the afternoon, *Variety Theater*.

CHRISTMAS SEALS

We did special promotions for Christmas Seals for several years. We did some special collections for Easter Seals as well, but it was the Christmas Seals collections that were the most fun. I'm sure the success of these

Bill Riley raising money for Christmas Seals. *KRNT/KCCI Television.*

promotions was the result of a gentleman named Ted Sloma, secretary of Polk County TB and Health Association. He was such an enthusiastic gentleman.

When I asked him one year during an interview on the *Noon Show* just what viewers might do to help, he said why not send in Christmas Seals to me at the TV station? Well, of course that was all it took.

I started asking viewers to send in their seals—and in they came! We didn't know what to do with the pile of mail until our *Noon Show* producer-director, Hurschel Weakley, suggested we start papering the *Noon Show* set.

The assistants loved the idea and went to work plastering the set with seals. The drive became an annual event, and viewers seemed to really enjoy being a part of it.

BUTTERNUT COFFEE DRIVE

Of all the promotions we had going on the TV shows, I think the Butternut Coffee Christmas Club was the most fun. I don't know whether

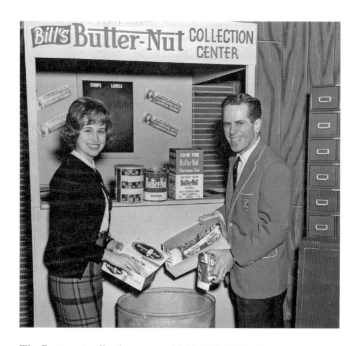

The Butternut collection center. *KRNT/KCCI Television.*

Butternut Coffee has survived the years, but back in the late 1950s and '60s, it was a very popular brand in Iowa.

Butternut had an established annual promotion at Christmastime, asking its customers to save the metal key and strip from cans of coffee. It purchased time on the *Noon Show*, and the result was automatic. I said, "Let's have folks send the metal strips to us on the *Noon Show*." The result was boys and girls literally queuing up each afternoon at *Variety Theater* time, loaded with key strips for our Butternut collection center. Our floor directors tried to weigh the strips to get some sort of an estimate of volume. All I know is that we trucked off hundreds of pounds of the strips; the count had to be in the thousands, and Butternut Coffee was one satisfied sponsor.

MARCH OF DIMES

As with any of our events, we did all we could to promote the March of Dimes. I had an interest in the project because it had been initiated by President Franklin D. Roosevelt.

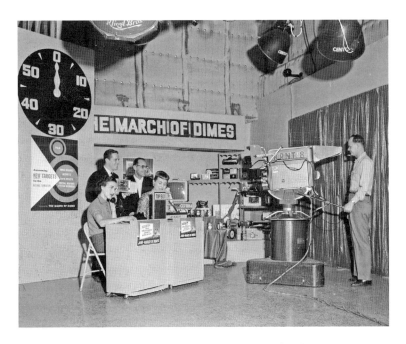

Raising money for the March of Dimes. *KRNT/KCCI Television.*

Our first efforts were way back in 1947 to 1950 on the *Hey Bob* show on KRNT Radio. We called our promotion the Parade of Pennies and geared it toward the boys and girls who were part of the *Hey Bob* audience. It was really fun, and each Saturday for a few weeks, we urged the boys and girls to bring their pennies. A Des Moines civic leader, Dick Olson, chaired the drive and always appeared on stage to receive the pennies—thousands of them!

Another stunt we pulled on the *Noon Show* during the TV years was my necktie trade. I really don't know how much thought I put into the gag, but one day on the show, I would trade my necktie for something else and keep on trading each day for a week or so until we had something of value for the March of Dimes. Of course, the March of Dimes officials were ecstatic because we were promoting them big time.

People responded, and I don't recall just how we handled the mechanics of the project. Nor do I remember any of the items we kept trading for. But I do know that we ended a busy week of trading with a really neat used car, a foxy Pontiac we sold for $805—all for the March of Dimes. Remember, this occurred back in about 1960, when $805 would buy a pretty nifty car—which it was!

One question still remains: who got my necktie?

TRIPS TO DISNEYLAND

What a fun project this was, and Union Pacific Railroad was probably responsible for the successful events. I credit Union Pacific because I featured special travelogue films from UP on the *Noon Show*.

UP supplied me with great travel features from the wonderful southwestern United States Union Pacific office, which was headquartered in Omaha, and it loved all the exposure it received on the show. At that time, UP not only served the great western United States, but it also maintained the hotels and concessions at many of the major national parks.

I don't know how I came up with the plan, but during one of our family camping trips, the idea came to me: why not make a trip available to some lucky family?

So how about a trip to Disneyland? Lucky for me, I had worked with Carole Bashnaugle on some radio shows at KRNT, and she had moved on to work for Disneyland. She presented my idea, and they went for it—a trip to Disneyland!

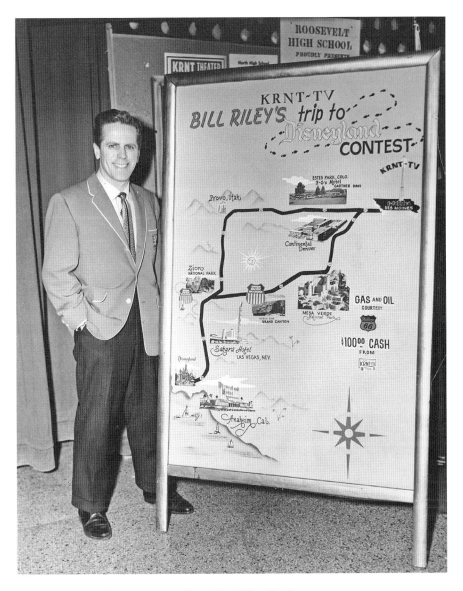

Bill Riley announcing a contest to win a trip to Disneyland.

Next, I went to Union Pacific, and they were happy to go along. Las Vegas was the tough spot, but again, I fell into a great situation when I discovered the promotion man at the fabulous Sahara in Vegas was an Iowan and excited to promote his beautiful resort. The rest of the spots fell together, and having made the trip two or three times to visit my

brother, who as a navy chaplain was stationed in California, I had the timing down quite well.

As I recall, we did three of the trips. The catch was, the winner had to agree to drive his or her car to California and back. Channel 8 added $100 in gas expense for the trip. We had three wonderful young families win, and most remarkably, I don't think we had one single problem with any of the three winners. The trip started, of course, in Des Moines, with the first stop at Estes Park, Colorado. We had fine friends at the Gartner Haus in Estes. From there, they traveled to Provo, Utah, for the next night. Then the excitement really began with Union Pacific playing host at Zion National Park. Next, the Sahara in Las Vegas and, finally, for two or three nights at the fabulous Disneyland Hotel at Disneyland. (Remember, Disneyland was very new in the late 1950s.) As I talk about it some fifty years later, I can hardly believe we pulled it off. But we did, and at some point in the past few years I had a man come up to me and say, "We'll never forget our trip to Disneyland.…Thanks, Bill."

ZOO MANIA: THE CHILDREN'S ZOO DRIVE

Of all the special promotions through the years, the Children's Zoo Drive was one of the biggest by far. It started one day in the 1960s. I was in my office when I was summoned to Bob Dillon's office upstairs at KRNT. Rarely, if ever, did I receive such a "summons," and as a result, I was a bit on edge as I entered Bob's office. A gentleman was seated there, and Dillon, a man of few words, said:

> *Bill, Mr. A.H. Blank has given the City of Des Moines $100,000 to build a children's zoo here in Des Moines. It will cost a lot more than that, and the city has come to me to ask our help in raising another $100,000 on Channel 8 so the zoo can be built. I told them we would be pleased to help and you, Bill, would be in charge.*

A bit stunned, I asked Bob Dillon just what he would suggest. He simply smiled and said, "Bill, building a zoo for the children of Iowa is up to you… just do it."

And that was how it all started. I went to my office, and on *Variety Theater* I made the announcement to the young viewers: "Iowa is going

Bill and Peg Riley (O'Connor) promoting a zoo fundraiser.

to have a zoo, and you, the boys and girls of Iowa, are going to see it built!"

I was so full of adrenaline that it was sloshing out of my shoes. The zoo drive started on that day and lasted exactly eighteen months, and never ever was there a day in that year and a half that Channel 8 didn't receive some money for the zoo. When the eighteen-month drive was over, we had not $100,000 but $158,000.

It took only a week or two for the young viewers to get it in gear. I remember driving around Des Moines in the summer, seeing youngsters with little lemonade stands for the zoo. (I drank my share, as I could never pass an anxious young zoo promoter.)

People on the *Party Line* radio show had all sorts of project ideas as well. The response was truly remarkable. I could feel it from the very start. As the months went by, our totals were small, as boys and girls' lemonade stand revenues were miniscule. I had a thought to go to the two gentlemen who owned the McDonald's franchises in Des Moines and ask them for help. I met with the gentlemen and came up with a brave proposal: McDonald's restaurants would contribute profits from the sale of French fries to the zoo.

I made the pitch. They listened and said they would call me. I really thought I had struck out, but a call came a few days later. It was the voice of Arch Madden, one of the owners. He said, "Bill, we are going to join the children and help you build the zoo!" I could have flipped—what big news! I said, "Great…profit from the sale of fries for a full day!" He said, "No, not that. What we want to do is take a Sunday, our busiest day, and donate total proceeds. Not just profit, and not just from the sale of fries, but our total revenue from all McDonald's restaurants for that full day."

I could have cried to think that two men thought so much of the boys and girls' efforts that they would literally put it over the top. I do not remember the figures, but when the receipts came in, our total surged and we never looked back. There were other businesses and individuals who added so much. I must mention the Des Moines Jaycees for their constant support, pouring thousands of dollars into the drive, as well as all the loyal *Party Line* radio listeners, who sold nearly twenty thousand pounds of fruitcake from the Wonder Bread Company.

Always very conscious of exact tabulation of receipts and donations, I tried to list every zoo drive contribution, down to the last penny. I felt that if a child contributed a few pennies that had been earned at a lemonade stand, it should be duly noted. So I got a big book—or binder—and did just that.

It was a big fat book, and we had it placed in the "castle" at the center of the zoo for all to see. Did you know that the original zoo had a big, curving slide from the top of the castle to the base? Boys and girls loved it, but when some overly exuberant adult went spiraling down and broke a leg, the slide was closed.

Now, some forty years later, how wonderful it would be for people to check the book and find their contributions made four decades ago. But the book seems to have disappeared. I have asked, but no one seems to know what

happened to it. Who knows, it may show up. Wouldn't it be fun to see the names of youngsters who helped to make the zoo a reality?

When the zoo was finished, I was honored to conduct the television tour of the facility. That would have been forty years ago, as I had a neat little boy on the show with me as he toured the zoo. His name, Bill Riley Jr., age eight. Today, he is the host of the *Bill Riley Talent Search* and one of central Iowa's premier home builders.

Now, the children's zoo is the Blank Park Zoo with a high-powered board of directors operating it, and my special friend Terry Rich is the chief executive. How proud the hundreds and hundreds of former young folks must be as they take their children (and grandchildren) to visit one of Iowa's finest attractions!

SCIENCE CENTER

Following the highly successful zoo drive, we launched right into the Science Center drive. Using the same appeal to all the youngsters, we worked on the project for several months.

The highlight of the Science Center drive deals with a relative of Mr. Ernie Sargent, a highly successful local businessman. The young lady met me outside Reichardt's Store in the Roosevelt Shopping Center in Des Moines. She identified herself and told me how impressed she was with the children's drive for the Science Center and said, "Bill, why don't you contact Mr. Sargent? I bet he might help." I thanked her and went right to Katie Meredith, who was heading up the drive, and told her the idea. She deflated my balloon, though; she told me Mr. Sargent had been contacted but had declined. But Mrs. Meredith said that if I wanted to try again, it sure wouldn't hurt.

So indeed, I did. I contacted Mr. Sargent and visited him in his office. I launched into my appeal while being a bit in awe of this gentleman. He listened very courteously and then said very humbly that he had never had the good fortune to study science and really was not tuned in to such an enterprise. Dejected, I was preparing to leave when he smiled and said, "What is this children's drive you are talking about?"

I explained the previous zoo drive and the efforts youngsters all over central Iowa were making to raise money for the Science Center. He asked if it might be possible for an "older man" to join the youngsters. Of course, I said yes.

Mr. Sargent called a gentleman into the office, and they conferred for a moment. Then he turned to me and said, "Bill, I would like to join the boys and girls' drive. We will add $50,000." What a thrill. I could have wept. I started to thank him when he stopped me and added, "That is for this year.... Now, how would you like to have another $50,000 next year?"

By this time, I'm sure I was in tears. What a truly wonderful experience in a lifetime of wondrous things. I never will forget a detail of this visit with a truly gentle man. There is an addition to this momentous afternoon in my life. Mr. Sargent said in parting, "Bill, you mentioned naming something at the center in my behalf....I really would like to decline."

When I reported all this to a very happy Katie Meredith, we decided he should be honored, and today the planetarium at the Science Center is the Sargent Planetarium, thanks to the gracious gentleman who wanted to join the children of Iowa in their desire to build the Science Center.

"JUNE DAIRY CARNIVAL"

The "June Dairy Carnival" was our contribution to promote June as Dairy Month, a campaign conducted by all the dairies of the area. The "carnival" was actually an outgrowth of the big promotions we had on the *Hey Bob* radio show before television, around 1959.

Anderson Erickson was one of my very special sponsors, so we always went all out with the "June Dairy Carnival." We awarded loads of prizes, and it was another fun event.

OPERATION SANTA CLAUS

With the arrival of television, we had the opportunity to bring Operation Santa Claus from the radio show *Party Line* to television.

We would set up radio transmitters in the studio and would be in contact with drivers all around central Iowa. Folks would call in with donations, and the operators would dispatch donation cars for pickup. This was always a fun, exciting event, and we looked forward to it each year for many years. Operation Santa Claus helped get us into the Christmas spirit. Events like this made TV so darned exciting in the fabulous early years.

Operation Santa Claus was a great project. *KRNT/KCCI Television.*

CHRISTMAS SHOWS

Each holiday season through a period of nearly two decades, I conducted Christmas shows for companies and organizations throughout central Iowa.

I remember going to Newton and, particularly, each year to Perry for the Oscar Meyer Company. We did two shows a day there because of the great number of employees. We had a great time in the Perry theater each year. In Des Moines, we did shows for the Meredith Company, the John Deere Union, the mail carriers' families—and on and on.

I also acted as master of ceremonies for shows booked by the Zarnow Brothers and Keith Killinger. The Zarnows were a great family! Ralph Zarnow was with the orchestra, and brother Paul—gentle, lovable Paul—and sister Sylvia. They all were in show business and never married, living in a big, old house located near Twelfth and University in Des Moines.

I often asked them why they didn't move. Ralph would always say, "We like it here, and we have nice neighbors." This was one area of Des Moines that had declined through those years. Ralph Zarnow also judged the TV Talent Show often and also at the state fair. What good friends they were.

I was working a show for the Zarnows on stage at the old Paramount Theater, and one of the acts I was to introduce was an old man (look who's talking). I honestly believe he might have been seventy or so, and he had a

performing horse every bit as old as he was (in horse years). It was the most awful old beast, with a sway back that eludes description. Now, the problem with this act was getting the horse down a long set of stairs on the east side of the Paramount. We all stood in wonder as the old gentleman lovingly coaxed the horse down those treacherous stairs. On stage, they were a big hit, as the horse did wondrous things for the wide-eyed audience, like counting, choosing colors and generally putting on a wonderful show.

Keith Killinger, like Ralph Zarnow, had a popular dance band of the era. Keith went on to actually be the director of the Ringling Bros. Barnum & Bailey Circus band. What an awesome career. And Keith's brother, Carl, was an outstanding music educator. Two great entertainment families of past years.

Ralph Zarnow used to schedule Duane Ellett and Floppy from WHO-TV to appear on lots of the Christmas shows; Duane and I were friendly competitors through the years. A side note on Duane: I introduced him many times, and we shared the stage on many occasions at the Iowa State Fair. I remember asking the crowd to welcome Floppy as I could see Duane coming through the huge crowd that had gathered to see him after he had just gotten off the air at WHO Crystal Studios across the fairgrounds. And always, as I would hand him the mic and tweak Floppy's nose, Duane would ask the audience to give a nice round of applause for, as Duane named me (and I am so proud), "Mr. Iowa State Fair."

SHOE STORE APPEARANCES

Throughout the 1960s, Red Ball Jet shoes were represented on the morning and afternoon shows. A gentleman named Dave Sherrard was the Ball brand representative for central Iowa, and he was a real promoter.

He talked me into making an appearance at one of Mike Weibel's Lazy M Shoe Stores. It was probably the store in the Highland Park Mall, which was new at the time. We pitched our appearance with candy bars for all and a load of prizes in the big drawing at the end of the hour (who wouldn't come for a free candy bar?).

Well, we arrived that Saturday afternoon about half an hour before the scheduled time, and the mall was jammed with boys and girls. It was a huge success, and Dave Sherrard couldn't wait to schedule shows all over central Iowa. We did these every Saturday during the spring months for about ten years.

One of many shoe store appearances.

I remember driving to Creston for our appearance. For some reason, the highway was blocked, and Dave Sherrard took a detour. After wandering over numerous country roads, we arrived in Creston more than an hour late. We thought we would have lost the crowds, but there they were, more than one thousand strong, whooping and hollering and having a fun time.

I would show the Red Ball full-screen and remind boys and girls to not wear any shoe that didn't have the Red Ball. I remember that in later years, the TV industry banned hosts like me from pitching the products, as I was doing. And no doubt, it was a wise decision. But, boy, we pitched the daylights out of products in the early days. And we had a great time with thousands of youngsters on the Red Ball Jet shoe store appearances.

BUILDING THE IOWA BIKE TRAILS

The final big effort on my part using the incredible power of the army of young TV viewers was the bike marathon era. It all started probably

in 1969, when I was on the Des Moines Park Board. At one meeting, the park director came before us to tell of a truly delightful pedestrian trail that extended from Ashworth Park to Water Works Park, about a mile or so, but was in sad need of repair. He said the trail was a muddy mess most of the time and should have a nice asphalt lane. There were no funds for such an ambitious project, and when asked, he said it would take about $12,000 to complete the trail.

Immediately, I thought of the wonderful army of youngsters who never turned down a challenge. So I blithely said, "Let me present it to the youngsters, and they will get it done!" I actually had no idea how I was going to structure the drive, just that the youngsters had come through on the other projects presented to them.

Almost immediately, I got a call from a popular young attorney named Bob Helmick. He invited me to his home to visit about the project. I knew of Bob and the fact that he had competed in the Olympics for the United States on the water polo team and later was an Olympics board member. Boy, I was impressed.

He asked what my plans were for the trail. I said I had none, but I did have an "army" of boys and girls who would tackle anything. Bob said he was conscious of a surge in interest in bicycle riding. I agreed and said I loved riding my ten-speed. "Well, why don't you rally the youngsters to participate in a bike marathon?" Bob said. Have them ride for dollars—what an idea! I couldn't sleep that night. Bill Jr. was working at Barr Bicycle. Jim Hoss, the owner, jumped on board, and the bike marathon idea was launched. It was a huge task, but things began to fall in place.

First, there needed to be a route for the marathoners to ride. I went to my friend Ken Fulk, secretary of the Iowa State Fair, and asked if we could hold the event on the grounds some Sunday in May. Without batting an eye, he said, "Yes, and I'll be your first rider to sign up!" What a guy! Without going through all the mechanics of board approval and other things, he just said "yes." I rode my bike around the inside of the fairgrounds along the perimeter fence, and the distance was two miles! The marathon would be twenty-five laps for a total of fifty miles. What a challenge it would be for the youngsters (and older bike enthusiasts).

Pledge sheets were printed, we pitched it on the TV shows and I visited every school I could in the Des Moines area. Everyone worked hard without having a clue whether it would fly or not. I really wasn't worried. I knew about the young army that could make it succeed. The *Des Moines Register*, in its generosity, gave the idea more exposure.

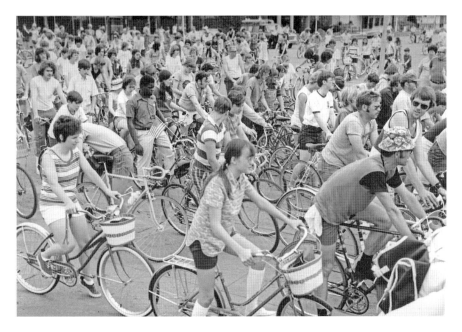

Bikers riding in one of the bike marathons held at the Iowa State Fairgrounds.

The weather was good, and hundreds of bike riders turned out. Not just the army of junior high youngsters, but moms and dads, too. As promised, fair secretary Ken Fulk was there with his single-speed bike. The riders checked in with the Des Moines insurance ladies and turned in their pledge sheets, got lap cards and lined up.

How proud I was that day to be a part of such an outpouring of enthusiasm for bike trails. Most of the participants completed their laps and picked up their certified pledge cards, and then came the hard part: going back and asking those who pledged to honor their commitments.

Remarkably, the "pay out" was nearly perfect. The money rolled in, and when it was all over, how much had the riders raised? Twelve thousand dollars, almost to the dollar—exactly what the park board needed for the trail. What was possibly Iowa's first bike trail became a reality thanks to those exuberant youngsters and that tough ex-marine named Ken Fulk, who went the total fifty miles.

Well, that was marathon number one. I conducted about twenty of them all around Iowa, from Clark Lake to Knoxville, including at Iowa State University and many cities all around the Des Moines area.

One of the fortunate things about all the bike marathons over about a four-year period was that most of them were coordinated by the city park

and recreation departments or special bike groups, who in turn took care of the collection of pledges and disbursement of monies raised to the various cities.

Although each marathon was very special for each community, a special second one for Des Moines was, for me, the prime event of the series.

I was still on the Des Moines Park Board, so I found out that plans were in the works to extend a trail all the way from Des Moines to a proposed lake site at Saylorville. Another marathon was planned for the fairgrounds. By this time, the Des Moines Jaycees were helping, as were the insurance organization women. It certainly was much easier to stage than the first one. However, that day in May dawned with a miserable light rain falling.

I could have cried but trudged on out to the site and found the workers arriving and carloads of bikes unloading. The rain continued to make it miserable, yet the ride went on as scheduled. And when it was all over, we had more than 1,200 riders participate. I just couldn't believe it. And what a celebrity affair it was, with Governor Bob Ray and his wife, Billie, and daughter; Des Moines mayor Dick Olson; Iowa attorney general Richard Turner and so many others.

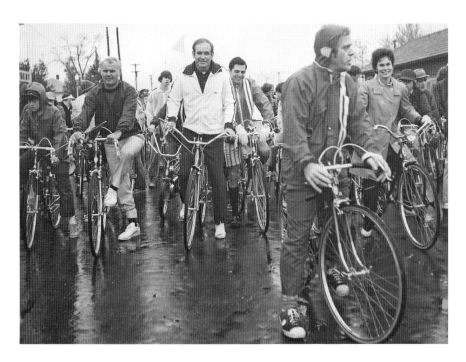

Bill Riley getting a bike marathon started.

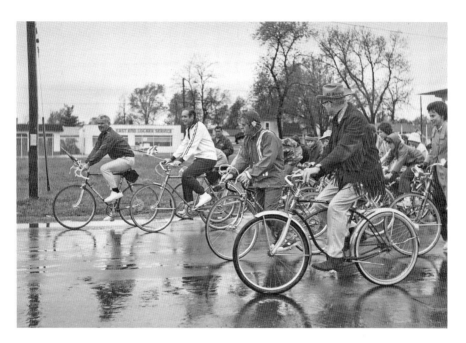

Rain didn't stop the bike riders!

Despite riders wearing rain gear and fighting slippery streets and a jammed roadway, the marathon continued and was a great success. Money raised? Thirty-seven thousand dollars. The money all went to lay the first segment of the trail that now extends from Des Moines to Saylorville through the Neal Smith corridor. This first segment, the start of the trail, began at the marina dock area and extended all the way to McHenry Park in the Highland Park area.

What an accomplishment by the hardy bike riders. They started the whole trail by their efforts on that rainy May morning. We salute you! You were building bike and pedestrian trails more than three decades ago, when bike riding was just coming into its own and trails were just on the planning tables. It's fun to have been a little part of history.

To cap our efforts, the City of Des Moines named the earlier Ashworth Trail, one of Iowa's first pedestrian trails, the Bill Riley Trail. What an honor. It's a reminder of all the enthusiastic youngsters and their moms and dads who helped start the Iowa pedestrian phenomenon that now exists.

IOWA PUBLIC TELEVISION

During these six decades of radio, television and cable television, I spent about twenty years or so as a volunteer on Iowa Public Television. As I look back, I realize that it was the tremendous man Bob Dillon, KRNT station manager, who made it all happen. You see, in this business of radio and TV, there is tremendous competition for the listener or viewer. Therefore, when I volunteered to work on *Festival* for IPTV, I was leaving my home base, KRNT and Channel 8, to actually work to promote another station and, even worse, go all out to endorse its programming and ask people to support that programming with contributions. Never, never in the thirty-some years I worked under Bob Dillon did he ever tell me to hold off or back off any project. It was just the opposite. Bob took a fatherly pride in my constant endeavors, even though he was only a few years my senior. I went ahead and was off and running in my intense desire to make Iowa Public Television the best in the nation, or at least to try. I started out just saying that I would like to help. I remember first nights on the *Festival* stage in the old IPTV studios, located in south Des Moines on Bell Avenue. I remember that when I started, we had about 4,000 "friends" of public TV. Today, that figure is probably nearing 100,000. My fleeting memory of the Bell Avenue studios was one March night when we had a spring storm and the rain was pounding on the old metal roof. It was a cacophony, a sound so noisy that we could hardly hear ourselves talk.

As my mind drifts back over those twenty years or so, I recall the strong feelings I developed not only for the mission of the public network but also

Bill works the audience at *Festival*. *John F. Schultz*.

for the individuals who worked with true devotion to the cause of trying to expand the television horizons. My first year or two made me a true believer and certainly an enthusiastic volunteer. My first year, I was on the air for one or two nights, but very soon, I eagerly moved to the general host for the entire week of *Festival*. I remember that the first few years we worked from

prepared scripts on the teleprompters that were mounted on the cameras. This changed early on, and soon we were ad-libbing virtually the whole weeklong appeal for funds.

As the program developed through the years, we had a wonderful format for my acting as host with usually just one co-host. In the "People Along the Way" section of this book, I remember and highlight some of those co-hosts (as I have said before, this is one of the primary reasons for this book—to remember the talented people of Iowa who played a role in our lives for the past sixty years).

I suppose we use the word family too often, but the IPTV staff was truly that: friendly, talented people, whether on the air or working behind the cameras. I remember the *Festival* that included an introduction of the big map of Iowa. This was a big task and was several years in the making. The art department felt that creating that big of a map would be a problem, especially trying to get such a huge prop on the set. Well, it was finally unveiled one year, and I was ecstatic. I could stand in front of that map and challenge one county to beat another—it was a delight. The only problem was that folks along the southern portion of the state didn't like me blocking the view of their counties. And we created a TV personality in her own right: our daughter, Terri, who came in most nights to post the totals as the "Map Lady." Terri always groused about the fact that the only way people would recognize her would be to view her from the rear, her position as she posted totals.

Speaking of the Map Lady, one night I received a call while not on the air from a lady who was upset with me for calling Terri the "Map Lady." For some reason, she took offense on the part of all womanhood for my calling Terri a "lady." Honestly, I do not to this day know the basis of objection, and I continue to call Terri by that name because it was all in fun.

When I speak of the "family at IPTV," I have to include the Friends organization. Again, these are volunteers who are dedicated to the station. Through the years, there were many different members of the Friends Board who were in the studio each night, always making sure we were happy. And that had a lot to do with feeding the workers. You see, the few "on-air" people were a small percentage of the total number of workers. Some thirty phones were covered by crews of volunteers who are to be saluted for their dedication. The hours created pangs of hunger, and the Friends volunteers were there each night with food from central Iowa eateries. And there were always homemade treats—like the final night each year, Millie Haynie, a longtime dedicated Friend, would serve everyone caviar as a finale.

Festival time at IPTV.

Bill and his daughter, Terri, at *Festival* on IPTV.

One thing I enjoyed was trying to add to the appeal of *Festival* through the years. The big map was one attempt, and so was the chance to salute Iowa artists by featuring a work of each artist as a gift for generous donors. The idea would be a win-win situation, with the artist gaining a world of publicity and *Festival* getting a work of art tailored just for IPTV donors.

I took the idea to Jim Vickery, president of IMT Insurance Company. Jim and IMT had long been sponsors of many of my projects on Channel 8, so he was a logical choice for me to present my idea. It went just as I had thought. I told Jim what I envisioned and that I needed a sponsor to fund the project. Certainly, you could not ask an artist to provide a work of art and not be compensated in some way. Jim didn't have to be sold and was ready to underwrite the project.

I already had the first artist in mind. She was my special friend Carolyn Blattle. Carolyn had done a Life of Riley rendering that Anne and the State Fair Board presented to me at my fiftieth Iowa State Fair, which I still cherish. My dream was to ask Carolyn to be our first Iowa artist to create a special work for *Festival*.

Carolyn came through like the creative wonder she is and came up with a wonderful work of art for IPTV. Jim Vickery was so very pleased. For his support of the project, IMT Insurance received the original, and

Bill working at *Festival* on IPTV.

Getting ready to go on air with *Festival* at IPTV.

hundreds and hundreds of Iowa families acquired prints by donating to Iowa Public Television.

I cannot leave mention of Jim Vickery without mentioning his wife, Dee. Jim and Dee always worked as a team in promoting civic activities, and being members of the Friends of IPTV Board was no exception. They spent many nights at the IPTV studios during *Festival*, helping make the annual event a success.

From my first moments as a volunteer until I decided I could not continue at the pace I was going, there was always one person who seemed to be there every night, every year, always making sure the volunteers were cared for. Her name is Win, the wife of Dr. Julian Bruner. I remember that one year we had a special night dedicated to her years of service. I feel it is only appropriate that I end my memories about the many wonderful Friends board members with a mention of Win, the person who during my many years was truly the motivating force, the soul of the Friends group.

The State Fair Highlights Show

Second only to *Festival* each March, my favorite master of ceremonies privilege was for the IPTV nightly Iowa State Fair program. Again, what a thrill to be host on one of the most widely viewed series of the entire year on the public network.

One great service IPTV has done for our state and the fair is to present this highlight show. Because Iowa Public Television is viewed not only in every nook and cranny of the Hawkeye state but also in all surrounding state border areas, the people of neighboring states have a chance each year to be thrilled by the highlights of what is, in my opinion, America's greatest state fair.

Because all of the work is done ahead of time by the excellent crews who roam the fairgrounds each day, the host's assignment is simply to tie all the filmed segments into the finished product. Each night in the big studio, the past day's events were relived.

However, Jerry Grady, who is the executive producer of the nightly shows, had a brilliant idea for a few years: to do the show each night live from the fairgrounds! Well, those few years were exciting, to say the least. Of course, we had all the film segments played from the studios in Johnston, but my portions were live. Can you picture this not-too-spry older man interviewing a giant man on stilts from atop a tall ladder or trying to do an interview with a pair of jugglers who were firing bowling pins at each other with me standing, shivering, between them?

One year, we were set up on a lovely hill overlooking the midway. The problem was that my chair was directly under the Sky Glider! Each night, people riding the Sky Glider took pot shots at me as they passed overhead. I remember being squarely hit atop my head only once—I was amazed that youngsters could chew a wad of bubble gum the size of a golf ball. By the way, Mr. Grady moved the site to another locale the next year. Thanks, Jerry!

Like all good things, I finally had to ask to be relieved of this assignment, probably the most enjoyable series I have ever been associated with. My good friend Mark Pearson was assigned the spot in my place. Darn it, Mark. Every time I tune in to enjoy your good work on the show, I wish I was still there. But it was time for you younger guys to take over. Have fun at the fair!

Part II

THE IOWA
STATE FAIR

STAGES AT THE FAIR

O ur sixty-year odyssey at the fair can be told by the many stages on the grounds. It all started in 1946 on the big stage in the International Harvester tent near the Varied Industries Building, as KRNT Radio brought television to Iowa for the first time. This is an appropriate starting point for our trip down memory lane, as the fair was literally starting up again after about a three-year hiatus because of World War II. So with the awful days of the war behind us, everyone was ready to face a bright new era and enjoy our great state fair again.

From this first stage, we moved to the old Women's and Children's Building, where we presented our *Hey Bob* show on the big stage there. Today, that old Hey Bob dummy, now more than fifty years old, is enshrined in a specially constructed case as one of the focal points of the Iowa Falls Historical Museum in the basement of the old Carnegie Library, now named the Ellsworth Carnegie Building.

From the late 1940s until the start of the Talent Search in 1960, we were on the stage of the TV studio building where KRNT originated shows and where we put on many fun events for boys and girls, like balloon blowing and bubble gum–blowing contests.

Each year was an exciting period of special events. I know one year I talked management into putting a voting machine at the entrance to the studio. It sure wasn't accurate but was very popular. I haven't seen any machines in recent years, but it's still a really fun barometer of an upcoming election.

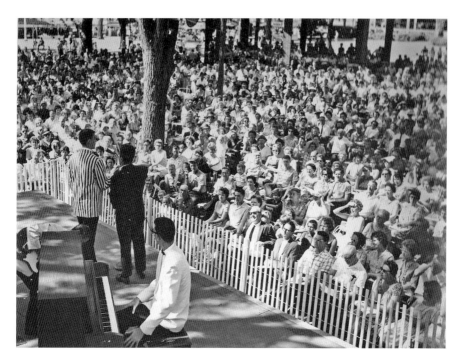

Big crowds gathered at the stage behind the Administration Building at the Iowa State Fair.

On the fair studio stage, I remember the Lennon Sisters, Rex Allen and many other Iowa State Fair celebrities as guests. When we cranked up the Talent Search in 1960, I started by a big tree in the extreme southwest corner of the plaza area. Then, Ken Fulk, fair secretary, built a nice new stage at the foot of the steps coming out of the Administration Building. In other words, at the extreme north side of the plaza (this actually was the best-positioned stage of all because the sun was at the spectators' backs). The next stage lasted only a couple of years and was way down at the extreme southeast corner of the plaza, where the "county stones" exhibit is now. Finally, Fulk and the board had a huge slab of concrete poured to establish the base for our current stage. This basic slab of concrete has held up incredibly well—not a crack after, I suppose, more than some thirty years. And now we have our wonderful big stage that is used to showcase a wide variety of entertainment, including the *Bill Riley Talent Search* each day at noon.

Now that takes care of the main stage, but during most of the talent search years, I was doing my 'little' show from other, smaller stages. I would put on little fifteen- or twenty-minute shows, featuring acts not quite ready for competition or winning acts of that day. We always had plenty

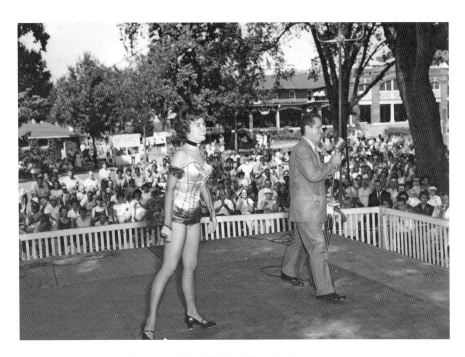

On stage during the early years of the *Bill Riley Talent Search*.

of eager youngsters wanting to hone their skills. These little shows were at 10:00 a.m., 11:00 a.m. and 3:00 p.m. I remember doing these shows in the 4-H Building and other venues until the fair board constructed a really fine cement stage in the shade of the grandstand building along the concourse, named, appropriately, the Concourse Stage. Many, many are the youngsters who first got a touch of being part of showbiz on that stage. Of course, I spent many hours on the huge Grandstand Stage throughout the years, but that is a story in itself.

THE RILEY STAGE

This spot, of course, is the home base for most of our activities and has been through the years. How wonderful it was in, I believe 1993, when the state fair board changed the name of the Plaza Stage to the Bill Riley Stage. A most humbling honor it was, particularly in view of the fair board's decision from the beginning not to name any structures or buildings for any individuals. What an experience to be the first to be honored in this way,

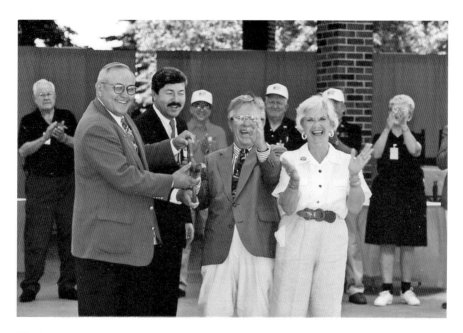

Member of the Iowa State Fair Board and then-governor Terry Branstad at the ribbon-cutting for the Bill Riley Stage in 1996.

and now it is a focal point of the fair, with the *Bill Riley Talent Search* each day at noon and great entertainment both before and after that time. Each morning, generally, the dance schools of the area take over with professional performances by their students. What a thrill it is to see swarms of little ballerinas lining up for their first chance to perform on the big stage. Each day following the Talent Search, the special events department schedules varied acts to keep the fairgoers entertained. At night, the top-flight professional entertainment is showcased.

As I look back through the years, some highlights pop into my mind. For instance, we came up with a state fair cheerleading competition for a few years and put it on following the Talent Search. We invited any cheerleading teams from Iowa schools to compete. Wow, it was popular! The plaza was jammed each day with the nubile youngsters and their super routines. I suddenly terminated the competition one year at its conclusion, however, when the person in charge of the Drake cheerleaders warned me of the possible liability with these young people doing some three-high formations. The Drake coach told me a school in another state had a student fall and be seriously injured with such a formation. I really appreciated her advice.

The Riley Stage also plays host to the annual Iowa State Fair Queen Pageant. What an event this has become, I remember emceeing the competition on the old Concourse Stage or up on the stage at the Youth Inn. We had thirty or forty entries at that time. Now it has grown to be a state fair premium attraction, with entries in the high nineties (there are only one hundred counties in the state). This is almost one entry per county! And what a thrill it is for the nearly one hundred queens representing their counties. I am so proud that Bill Riley Jr. has taken over the host duties. He does a super job presenting the young ladies and keeping them at ease.

Here's a stage story you'll get a kick out of. One year, the folks from the sheep barn suggested we might want to showcase the Ladies Lead Class on the stage. This a fun class for which the ladies dress up the lambs in wild costumes and lead them across the stage. Sound like fun? It was. There was a big crowd, elegantly garbed lambs and proud owners. However, the only problem was the lambs became nervous with all the excitement and defecated quite often. It took the crew some time to get the stage back in working order again. (I think we did that only once.)

The most fun on the stage was to introduce important visitors to the grounds. Senator Bob Dole was a really neat guy who just couldn't stop making wisecracks—what a sense of humor! And I remember that a Secret

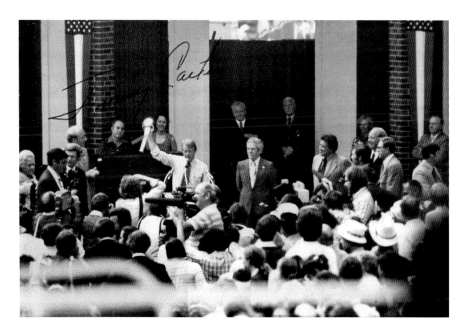

President Jimmy Carter visited the Iowa State Fair.

Service man told me to put a glass of water on the senator's left side. He said it was very important. This was the first time I realized the senator had only minimal use of his right hand and arm due to a war injury. That's why Senator Dole always carries a pen in his right hand—to stop people from reaching for that hand to shake.

And then there was Jimmy Carter. Anne Riley really made the show when she had me present candidate Jimmy Carter with the Talent Search Blue Ribbon as a special gift. He seemed so pleased with this small ribbon, and the *Des Moines Register* really went for it the next morning. There was the front page of the *Register*, with candidate Carter holding the blue ribbon high above his head.

Yes, the big stage is a truly magical spot on our stately fairgrounds, where you might see a tiny four-year-old ballerina in her tutu or maybe the next president of the United States!

The Grandstand Stage

Of course, the biggest stage of them all at the state fair is the Grandstand Stage. During recent times, it has been on a railroad flat car–like contraption so that it can be moved in and out of center position. My memories of the great stage tumble before me from my earliest days. I was so frightened when the shows ended with the giant fireworks displays. That would have been in the days when my mother took my brother and me to some grandstand attractions when we were just little boys. Those aerial bombs really got to me—I hated them! But in current years, I love the mighty displays. And when I was a fair board member, we used to stand on the roof of the Administration Building many nights for an excellent view of the pyrotechnics. Watching them every night was always an exciting experience.

Back to current times. I always tried to be available afternoons and at night in case a featured act needed a special introduction. Most acts did bring their own emcee and usually enjoyed having someone bring them on stage. Several times, however, I would introduce a special *Bill Riley Talent Search* act before the main act. One I remember in particular was a tiny four-year-old boy in costume doing an Elvis impersonation. He was just a darling child and actually very good. He had all the moves. I put him on before the headline act one night, and he just wowed the ten

to twelve thousand fairgoers jammed in the stands. What an incredible experience for a young person!

Another youngster who was involved backstage but did not perform was Walter Henderson, a superb young vocalist of about twelve years. The night Lawrence Welk was to perform, I arranged for him to meet Walter backstage. Mr. Welk was so considerate and I'm sure did much to bolster Walter's ego. I had hopes that Mr. Welk would bring Walter out to California to work him into his wildly popular show, but no luck. We tried, though, and you never know when some little effort, like that night, could kindle a wonderful career for a talented youngster.

As I look back over a host of memories of the Grandstand Stage, I have to report on 1986 and the climax of "Homecoming 1986." Our yearlong efforts to make Governor Terry Branstad's idea of a special homecoming year for Iowans ended one August night just before the Iowa State Fair with a gala stage production orchestrated by Terry Rich. It was a wonderful salute to Iowa, and thanks to Dan Miller and all our friends at IPTV, the entire show was carried live across the state. (Sometime when you are writing a check for IPTV during *Festival*, remember that special events like this go way back to 1986, and the *Bill Riley Talent Search* "Championship Show" is broadcast on the final Sunday of each Iowa State Fair. Thank you dear friends of IPTV!)

A big-name star, Merle Haggard, was scheduled for an afternoon performance. About 2:30 p.m. that day, someone from the office came rushing to our stage to tell me that there was an emergency at the Grandstand Stage and that they needed me. I had just finished the Talent Search, so I rushed over to the big stage to find our celebrated country entertainer in his trailer, waiting to go on. But there was no big sound system for him. Fair officials thought he was bringing his own; he thought the fair was providing one. We did have a small setup for announcements, but that was all. I was informed that an emergency system was being rushed to the stage, but it was my job to try to keep a really large crowd of five to six thousand people halfway content for an hour or so. I wish I had a tape of that afternoon because we rounded up a bunch of the talent acts who had just been in competition.

After almost an hour, we were running out of ideas when I thought of my dear friend Dean Davis, "the Turquoise Man," who had his big display of wonderful southwestern art at the northeast corner of the Varied Industries Building. Dean and I had been friends for years, and as a matter of fact, Anne and I helped talk Dean and his wife, Jaci, into their annual visits to the fair nearly thirty years ago. It so happens that I knew Dean was a

professional entertainer in his own right and entertained troops on the USO circuit. Luckily, Dean had his guitar and rushed to the stage to present a concert of his own. The crowd loved him, and he got three standing ovations for his efforts. Finally, after an hour and a half, the big PA system was in place, and Merle performed.

Just before Merle went on, one of his aides came to Dean Davis and me and said that he wanted us to come back to his trailer so Merle could personally thank us. We did, and there he was with a couple of friends. He said, "I understand you guys filled for me. Thank you." Well, what an honor to meet a country legend, and my good friend Dean proved what a showman he really was!

Red Skelton was another famous performer to grace the Grandstand Stage, and he said he would be pleased if I were to introduce him. Boy, that was a thrill! I asked just how he would like to be brought on. Mr. Skelton simply said, "Bill, go out and simply say: "Welcome one of America's clowns!" What a lesson I learned that night. As I went to the mic, the crowd quieted, and I simply repeated the words. As I said, "Welcome one of America's clowns," the crowd just exploded in a welcome that would make any Iowan proud, and I'm sure it impressed Mr. Skelton. After bringing him on stage, I went out into the audience to enjoy the show. However, I read in the *Register* the next morning that Mr. Skelton collapsed backstage after the first part of his show. It was a miserably hot, muggy August night, and it took its toll. I understand, however, that he managed to return and finish his act like the true professional he was.

Two little sidebars to the Red Skelton story. I heard later that Red relieved tension before a show by etching clown figures on his dressing room walls. Boy, wouldn't that be a collector's item to own! While visiting with him before the show, Mr. Skelton told me he always was a bundle of nerves, hence the reason for the clown pictures. However, he said that the minute he stepped on stage, the butterflies disappeared. I have told this story to youngsters a hundred times and always tell them, "Mr. Skelton has a nervous stomach before going on stage, just as you do. However, when you step out in front of the crowd, the butterflies will disappear because you are a performer; you have talent, just like Mr. Red Skelton."

Although the memories continue to flood in, we shall finish up our memories of the Grandstand Stage with a true highlight: being master of ceremonies for President Gerald Ford's visit to the Iowa State Fair.

After working through all the necessary clearances from the Secret Service for several weeks before, the big day came. President Ford was to visit the

state fair and deliver a major address to Iowans jammed into the grandstand some twelve hundred strong!

It seems the president was scheduled for a 3:00 p.m. address on a beautiful August afternoon. I started in on the mic at about 2:30 p.m., gabbing away about what a historic moment this was for us to actually enjoy the presence of a sitting president.

As 3:00 p.m. approached, I started to get reports from the two Secret Service men who were standing beside me on the big stage. I was informed that the president was leaving Hotel Fort Des Moines downtown. Even with an escort, that would mean a long time. So I notified the audience of the progress of the caravan. To my dismay, I noticed folks getting up to leave, so we kicked up the rhetoric and again stressed the importance to children, especially, of being able to see a sitting president in their lifetime. Well, things began to pick up thanks to the Secret Service, who kept telling me where the caravan was.

When I announced that the president was entering the fairgrounds, we got a big cheer and then suddenly a groan as I announced the caravan had stopped at the 4-H Building for a visit. But that was brief, and soon I announced that the caravan was at the paddock gate, where cars come on the track. This was fun. I was loving it! All of a sudden, the president's car stopped, and out popped President Ford, a city block from the grandstand! My two Secret Service agents literally flew off the stage to join their fellow agents, surrounding the president as he walked along the fence, just having a ball touching hands, kissing babies, having what looked like the time of his life while the Secret Service agents must have aged a few years in those few minutes.

Back on stage, I was loving it as I watched the president of the United States approach the stage. I was standing there all alone when suddenly this man—the president of the United States—popped up ahead of everybody, stuck out his hand and said, "My name is Jerry Ford. Where do you want me to sit?" I'm sure that, for once in my life, I was speechless!

After the president had finished his address before a crowd brimming with Iowa hospitality, everyone was going his or her own way when an aide to the president came up to me and said, "President Ford knows what you did today for almost an hour and wants you to have this set of presidential cuff links as his personal gift." As I continued walking off stage with then-congressman Neal Smith, I commented on the gift and maybe didn't seem too excited. Congressman Smith said, "Bill, lots of people in Washington have presidential pens, but few have been presented with the presidential seal cuff links personally by the president." Neal Smith added that I should

not just put the trophy in a box but that I should mount the cuff links for my family to have as a record of this day. To top that off, within the next week, I received a wonderful thank-you from the president. And yes, I have the letter from President Jerry Ford with the cuff links mounted beneath.

11

BILL RILEY TALENT SEARCH

I am very proud of my association with Iowa Public Television through the years, and during the Iowa State Fair, we really had fun. Not only did we do special reports each day for the nightly fair coverage, but also the entire championship talent show has been carried live or on a delayed basis on the final day of each state fair.

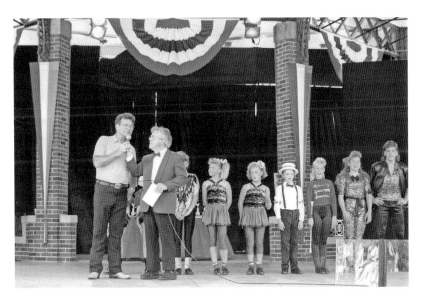

Marion Lucas and Bill Riley at the *Talent Search* awards.

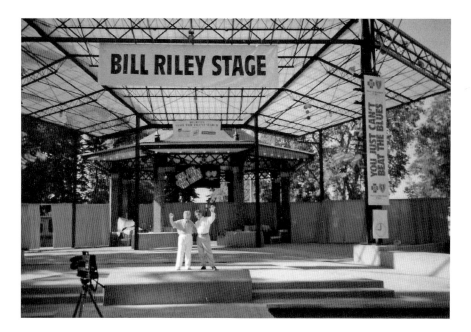

Bill Sr. and Bill Jr. at the Iowa State Fair.

This championship broadcast has been a tremendous event, not only for the young folks on the show, but also for the show itself. It takes the excitement of that final day of the fair to all Iowa and border state areas. What a wonderful thing this has been for the show. And it certainly has been responsible, in part, for encouraging county fairs and town celebrations from all around the state to sponsor local talent shows each year, with winners advancing to the state fair. But the greatest plus comes, I feel, in the incredible opportunity for young Iowa performers to display their talent on statewide Iowa Public Television. Just think, these young folks appear on TV with the potential of being seen in more than one million TV homes! Truly a once-in-a-lifetime experience.

I won't spend any more time visiting about the Talent Search because we covered the first forty-five years of the show in a book, *On Stage: Bill Riley and Tales of the Talent Search*, which was published for the 2004 state fair.

I cannot leave this section without thanking my son, Bill Riley Jr., and Terry Rich. They kept the show rolling when I retired from the master of ceremonies job. As a matter of fact, the show has grown dramatically since their infusion of talent and enthusiasm. And with Terry Rich moving to the zoo directorship, Bill Jr. has taken over the entire show in the past four years. How proud can a dad be?

Part III

PEOPLE ALONG THE WAY

In a lifetime dedicated to enjoying untold activities and the resulting contacts with hundreds, even thousands, of interesting people through the years, it is quite impossible to select a few, or even many, without omitting a small army of interesting people. But I am going to try to stop and mention a few of the people I have met along the way.

KRNT/KCCI STAFF

BOB DILLON

Early radio personnel in the 1940s included a "second lieutenant," Bob Dillon, who returned to the station in 1946 as general sales manager. He soon rose to the position of general manager at KRNT and was my mentor and inspiration through the next three decades.

A gruff, intimidating man, Bob Dillon was gentle and very considerate under that somewhat frightening exterior. Each year on the anniversary of my employment, I would venture into Bob's office and simply say, "Bob, I've had another wonderful year working for you. How about letting me work for you another year?" Bob would get up, put his arm around me and respond, "It's a deal—another year!" And he would always add, "We'll conquer the world!" That would always inspire me for another productive year.

GENE EMERALD

Gene was one of my best friends during the early days at KRNT. He had the prime afternoon show on KRNT, about 3:00 to 4:30 p.m. He had to be in his mid- to late fifties and was an old-time vaudevillian. He played guitar and could sing very well. His program consisted of folksy visiting plus live

music. He had an organist each day on the show. The organist's name was Don Miller, and he was good.

Gene also promoted some local talent, like Mimi Evans, a high school girl from a small town north of Des Moines. She would come in a couple afternoons a week and sing. Gene and Don would back her up. She was a very pretty girl and had a fine voice.

Gene was a caring person. I remember he talked often about a young man named Billy Walker from Greene, Iowa. Billy had been paralyzed since birth and could hardly speak. Yet almost every day, Gene would send a song along for his buddy Billy. When Billy would come to the studio to visit, I was always amazed at Gene's true compassion for Billy.

Gene's daughter, Ila Rae, lives in Iowa, and she not only resembles Gene but also has inherited his warm, caring manner, as she devotes much of her time to aiding those who are less fortunate.

BOB ELGIN

Peg Riley (O'Connor) with her new friend at the zoo.

I have mentioned the zoo show on Channel 8 and the man who made it so popular, Bob Elgin. As director of the zoo in the early days, Bob injected excitement into what was, at the time, quite a small layout.

Right away, Bob and I set up the Children's Zoo Show at about noon each Saturday. Bob always had interesting animals to show and describe. I have mentioned before the giant snake, a boa that my daughter Peggy was showing, and how she suddenly asked Bob to remove it from her shoulders. After the show, I asked why, and Bob said the snake had hissed, and Peggy knew he might strike her. I said, "But boas are not venomous," and Bob responded, explaining that if it

had stuck her in the face, it would have done terrible damage to her. I could have cracked Elgin for even letting Peggy near the snake!

Bob was struck by snakes many times at the zoo and recovered, so he'd built up an immunity. He was in demand around the country to rush someplace to give a transfusion to someone who had been bitten by a snake. I always teased Bob about suffering from permanent snakebite.

MARY JANE CHINN ODELL

Mary Jane Chinn—what a wonderful person. It all started on that day in 1955 as we went on the air with KRNT Channel 8. Mary Jane and I were assigned a small office with two desks pushed together just outside the TV studios. Crowded, but who would care? We were on TV!

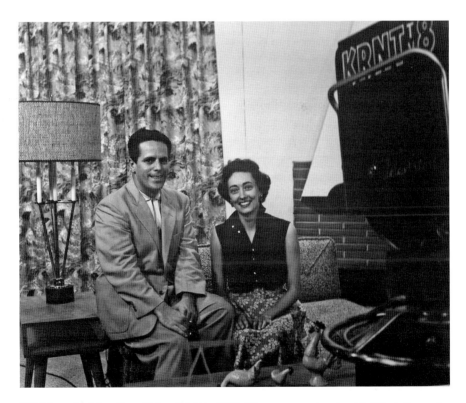

Bill Riley with Mary Jane Chinn Odell in 1955. They were on the air with *What's New* each day at 11:00 a.m.

Mary Jane and I continued to be great friends and actually shared that small office for probably fifteen or twenty years. It was this office that provided me with the privilege of meeting interesting guests Mary Jane would have on during her interview show. As we had no "green room" at KRNT for guests to use prior to their on-air interviews, those guests would be in our office, which would give me a chance to become acquainted with them. I loved meeting the celebrities.

Mary Jane also had a show featuring interviews with prominent folks. It was this show that really meant so much to me, as her guests would sit and visit with me while she was in the studio getting set. It was just such a situation that got me to be so fond of Meredith Willson. Several times we sat and visited about Iowa and the wonderful state we both loved (I still think "Iowa, It's a Beautiful Name" should be our state song).

For nearly twenty years, jammed in that tiny office—never a short word, always a wonderful smile and a resounding laugh, always as friends, my wonderful friend Mary Jane Chinn!

Mary Jane went on to win Emmys in Chicago TV. She came back to be Iowa's secretary of state, and Governor Terry Branstad named her co-chair to serve with me on the governor's big Homecoming '86 project, which involved more than one thousand events throughout Iowa that year. Mary Jane Chinn, you have given so much of yourself to our great state. Thank you!

GUY KOENIGSBERGER

Few would recognize the name Guy Koenigsberger. However, if you say, "Ko-Ko the Klown," there would still be lots of Hey Bobbers who remember the antics of Ko-Ko on the *Hey Bob* show nearly sixty years ago.

It is so hard to realize that the Hey Bobbers of 1948 and 1950 are now in their sixties and seventies. That is one reason for this book—to try to preserve a few memories from half a century ago. Of course, the *Hey Bob* show was broadcast live from the Paramount Theater in downtown Des Moines each Saturday morning from 9:30 to 10:00 a.m. Ko-Ko the Klown became a very important part of these shows during the four years of *Hey Bob*. Actually, Guy K., as we knew him, was a special projects development specialist for KRNT Radio. So the *Hey Bob* show was tailor-made for his outgoing personality and talent. We all learned early on to keep Ko-Ko a healthy distance from very small children so as not to frighten them. Ko-Ko was beautifully made up by his wife, Marvel, who was the makeup specialist for the Des Moines Theater

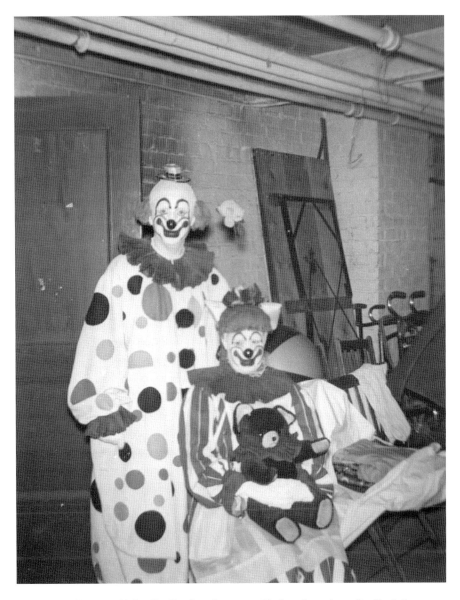

Ko-Ko the Klown and Mrs. Ko-Ko clowning around before show time. *Guy Koenigsberger.*

Association. As a matter of fact, Marvel became so attached to the *Hey Bob* show that she transformed herself into Mrs. Ko-Ko the Klown.

Beautifully costumed and professionally made up, they were a great addition to the show. One of our very best stunts would be to give youngsters a chance to hit Ko-Ko with a huge crème pie! Of course, he never got hit.

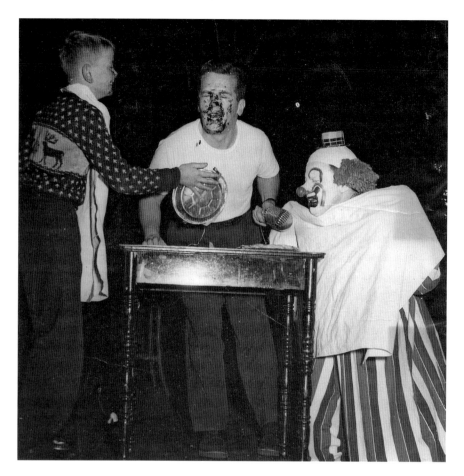

Getting hit with another pie.

We always cued the child to miss Ko-Ko and hit me with the pie instead. Believe me, I was hit with as many pies as Soupy Sales (a comic of the time whose trademark was being hit by pies). I always wondered what would have happened if the child got his or her instructions wrong and did hit the artfully painted Ko-Ko's face! Well, it never happened—I always got hit.

One time, we couldn't get crème pies, and I was hit by a blueberry pie. The child was husky, and he hit me like a truck! I was disengaging blueberries from my nose for the rest of that show. Only crème pies were used in the future.

Ko-Ko made such a name for himself that he was chosen to "troupe" with the celebrated Emmett Kelly and the Ringling Bros. and Barnum & Bailey clowns when the circus came to town. How proud we were to watch our own *Hey Bob* clown troupe with the most famous troupe of clowns in the world!

DOLPH PULLIAM

During nearly four decades of great excitement generated by the likes of Bill Evans, John Pritchard, the Ulrichs and Red Murrell, there was one Drake Bulldog who always stuck in my mind: Dolph Pulliam.

I started admiring Dolph Pulliam when I first introduced him as a Drake basketball player many years ago. From the start, Dolph gave evidence of his leadership qualities. On the Drake team, he was a true standout, and we had some fabulous games of Drake Bulldog basketball.

After Drake, Dolph joined us at Channel 8. Actually, I found out later he could have signed a contract with a pro basketball team and made a fortune; he was that good. But he chose to stay in Des Moines and ultimately went on to join the Drake staff, where he has been so successful.

Of course, our time together at Channel 8 is why Dolph meant so much to me, and we were true friends. "Big Dolphus," my special name for Dolph, was always smiling, and he was always fun to encounter as we performed our daily tasks.

I even remember how pleased Anne and I were one Thanksgiving when Dolph chose to share it with us at our home on Forty-fourth Street in Des Moines (I'm sure he had more than one invitation). The Riley children were captivated at having this "superstar" at our home. I loved having him there, too; I just worried he was going to break one of our dining room chairs!

To me, my friend Dolphus is a giant of a man but the gentlest, most caring person you could ever hope to meet.

IPTV

BEHIND-THE-SCENES STAFF

DAN MILLER

When I try to select a few special people along the way from my years at Iowa Public Television, it borders on the impossible. So many good friends, so many most appreciative, talented young folks. But it is easy to start with a

Bill and Dan Miller having a conversation. *John F. Schultz.*

PEOPLE ALONG THE WAY

very gifted young man whom I have known before and beyond my two decades at IPTV: Dan Miller.

I say before the TV years because Dan was in school with some of our children and often visited our home in Des Moines as a youngster. He was probably in the basement with half the neighborhood listening to my son Eddy's band, the Wichita Flash, rehearse.

I was so pleased to watch Dan advance through the management plateaus at the network and finally end up at his current position as the director of IPTV. What a wonderful achievement, and how very proud I am to have known and worked with Dan through the years.

I always took a special interest in Dan's activities on the air because his mission at the network has always been administrative. However, I also felt Dan was a most convincing on-air person, so I always urged him to work alongside those of us who volunteered for *Festival* each year. Although a bit hesitant at the start, he took hold and has performed like a champ for years. As a matter of fact, Dan has now moved to a role of spokesman for the network—and a most effective one, to boot. Good work, Danny!

DUANE HUEY

This is a young man who does not sleep during *Festival*! Well, almost no sleep, as Duane is the executive producer of IPTV *Festival* and has been for at least the last twenty years. He is the talented young man who is in charge of the whole operation, and I'm sure the sheer logistics of the production are mind-boggling.

At first contact years ago, Duane was a special person to me because he was the son of Bill Huey, chief engineer at Channel 8 much of the time I was there. Prior to meeting Duane, Bill Huey and I had a wonderful relationship. We always had a bit of nonsense going, as I would get onstage to begin a show, and Bill Huey, with much fanfare, would march in and check my necktie to make sure it was tied just right (I always wore a shirt and tie on camera). Silly, yes, but a moment of fun almost each day. We have lost Bill Huey, but I will never tie a necktie without making sure it is as near perfect as possible (my Bill Huey training).

But back to Duane Huey. His nickname is "Deuce," although I don't know where he picked that up. Much like his dad, Duane is a most caring person and made *Festival* a lot of fun.

Duane Huey deserves a medal for his work with me on camera through the years because I have a tendency to try to direct a program from the floor or in front of the cameras. This is the scourge of any director, to have some guy out in front of the camera doing the opposite of what the director wants.

Well, you must remember that *Festival* is completely freewheeling, without a prepared script. It is mainly ad-lib, which I love, just wheeling along, pitching IPTV and asking for support from viewers. Duane, who was producing the show, had to conform to a rigid format of joining the PBS network and inserting films and a host of other things.

He would be trying to get all this done to perfection, and there would be Bill Riley always asking for more time to continue his on-air presentation. Duane always kept his cool through the years because he knew we both had the same goal: we both were anxious to do a good job for IPTV, and we had enough respect for each other to have our traditional hug at the end of each *Festival*. It was great fun, Duane, well done!

JERRY GRADY

Another of the executive producers whom I had the pleasure to work with through the years was Jerry Grady. As the name readily establishes, Jerry is a true Irishman and very, very proud of that heritage. As a result of this common ancestry, we got along famously from our first meeting.

That first meeting was many years ago, as Jerry—or "Grady," as everyone knows him—has been producer of the Iowa State Fair coverage for many years. This included my hosting duties on the very popular nightly fair coverage and the same-day presentation of the *Bill Riley Talent Search* finals on the last day of the fair. What a pleasure it has been to work the fair shows.

Here's a Jerry Grady story you have probably never heard. Remember the introduction to the nightly public network show? A montage of state fair activities, one shot shows a husky young man grappling a huge live bear. It is only a fleeting moment, but that burly young bear wrestler was…you guessed it, Jerry Grady, distinguished, talented producer of the fair shows on IPTV.

IPTV

Co-Hosts

This section on the people along the way from Iowa Public Television is probably the most important, at least in my eyes. On these pages, I want to pay tribute in this small way to the co-hosts of the many *Festivals* through the years. And to take over this most difficult assignment, I asked a dear, dear friend, Colette Downey, to help. I have known Colette through the radio and TV days on Channel 8 but more recently at IPTV, where she held an administrative position until her retirement a couple years ago. No one knew more about the *Festival* phone bank than Colette.

She was in attendance all the time at each *Festival*, always sitting in the number one phone position and always with her big book, which chronicled each night through the years. I used to laugh when she would report down to almost individual hours about the corresponding phone calls from past years. If anyone was truly the pulse of each year's *Festival*, it was Colette Downey.

Colette helped me remember the co-hosts from *Festival* shows past. These names represent the heart of *Festival*, day in and day out, always pitching a love of IPTV and sharing an intense desire to help Iowa Public Television be one of the very best in all the land.

BOB DORR

It is fun to think back over some twenty years of *Festival*s and all the good times. I never knew who the co-hosts might be, as they were different each night and selected by our producer, Duane Huey. But I never will forget the night Bob Dorr joined us for the first time. Bob Dorr was a favorite of mine, the man who fronted the musical group the Blue Band. I have enjoyed it through the years since the Blue Band is an Iowa State Fair fixture "up on the hill" at the Anderson Erickson Dairy Stage. It was no surprise to watch Bob master the television audience, just as he has done through the years as the leader of one of Iowa's best live acts. It was a very special evening as we became acquainted on TV in front of over one million TV homes. How much I enjoyed spending that *Festival* night with Bob Dorr!

MORGAN HALGREN

Morgan was on *Festival* with me probably more than anyone else during all those years. What a remarkable person. I was so impressed to learn that Morgan is bilingual and has done commercials on Hispanic stations. Of course, you have also seen Morgan on *Living in Iowa* as she finds interesting stories from around the state. Also, she appears on the Iowa Public Television coverage of the state fair show each year.

Morgan was lovely and a true delight to co-anchor with. But I have to admit that I looked forward to the nights she and I would co-host *Festival* for another reason: the goodies baked annually just for me. Thanks, Morgan!

TERRI HALE

Terri Hale was another super co-host to work with. She came to *Festival* years ago. We actually were still on Bell Avenue, so it has been many years. She was a newsperson at a TV station in Sioux City and was really good.

Terri has done many, many *Festival* shows and is so good—a real asset to each year's *Festival*!

DEAN BORG

I always looked forward to the nights that Dean Borg would be co-host. There never was a problem; everything was done with true class.

Dean came in each week to tape his popular *Iowa Press* program on IPTV. Those would be the nights Dean and I would share the mic.

PETER HAMLIN

What an addition to the fine cadre of super co-hosts on IPTV. Peter is most gifted and has a flair for the comedic, as is evidenced in his many enjoyable appearances on the IPTV state fair series throughout the years. At *Festival* time, I always looked forward to Peter standing there, across the big studio, ready to pep up the evening.

MIKE FRISBIE, DEL MONICO, TODD MUNDT AND LARRY MORGAN

Was this ever fun! Years ago, on one Friday night of *Festival* at about 11:00 p.m., a scraggly group of people suddenly started moving into the station auditorium. I couldn't believe their various degrees of really weird costumes. I discovered they were the "Whovians" from Omaha, Nebraska, who had come over to enjoy the *Dr. Who* show. Being of the old guard, I had no idea who Dr. Who was. The coordinator and late-night co-host was, of course, Mike Frisbie from Clear Lake. We might call him the Grand Whovian.

Now we are stretching back many years. I just always remember Del Monico as a very popular DJ on a smooth and professional top forty–type station who was a breeze to work with.

The same is true with Larry and Todd—both top announcers and real pros, just like Del. Thank you, Mike Frisbie, Del Monico, Todd Mundt and Larry Morgan!

BOB MCCLOSKEY

One young person who will stick in my mind was a Drake student named Bob McCloskey. Bob went on to enjoy a very nice job at IPTV (you heard him a hundred times as he announced upcoming programs on the station). I was notified some years ago that Bob died quite suddenly. How awful! I have another memory of this dear friend. I used to see him at lunch. He used to like to take his mom out for a treat—what a wonderful guy Bob McCloskey was!

PAT BODDY

A regular through the years, Pat Boddy was a really cool, collected co-host—always ready, always able to ad-lib through any time period necessary. I was amazed when we first met and became acquainted. She informed me she was an engineer! Yes, a civil engineer at a prominent Des Moines firm. She just did TV as one of her volunteer projects.

STEVE GIBBONS

Now here is a friend for a long time. Steve joined KRNT Radio many years ago as a board announcer who advanced to personality status very quickly. The opposite of the yell and scream of some radio stars, Steve was always subdued and enjoyable to listen to. He was the same when he volunteered for co-host on IPTV. It was so much fun to share the night with Steve Gibbons on *Festival*. One night, he surprised me by saying he'd had cataract eye surgery just the day before!

MARK PEARSON

Mark didn't co-host too often because he was busy with other permanent IPTV shows like *Market to Market*. Did you know that *Market to Market* is televised around the country? And of course, he does the Iowa State Fair

highlight shows each year. Did you know Mark Pearson once was a headliner on WHO Radio and once ran for secretary of agriculture in Iowa? A remarkable gentleman, Mark Pearson.

RICK SWALWELL

I always kind of thought of Rick as being like me. His on-the-air manner, his desire to try and help, whatever the job may be—he's kind of a "utility type" outfielder, as they say in baseball. A good handy man (now that's a compliment for you, Rick). As a matter of fact, I often thought Rick Swalwell would take over the *Bill Riley Talent Show* at my departure, before my son Bill Jr. took over.

CHET RANDOLPH

What a dear, sweet, gentle man he was and just the opposite of Dean Borg's precise, nearly perfect presentation. Chet was like a good old boy, with that deep, golden voice I would have killed for.

Chet was not familiar with working as a co-host, having one spokesman on one side of the studio and one on the other side, shooting it back and forth. The nights Chet would be on with me, I would switch to him to regroup for a moment and would see him coming toward me out of the corner of my eye, and I would hear that wonderful booming voice saying, "Well, Bill, how's it going over there?" And with that, he would be standing beside me to visit. I could just picture the people in the control room having a fit because they had their two hosts in one shot. Of course, it was not a big deal, but I'll always remember Chet Randolph and that golden voice saying, "Well, Bill...!"

15

PEOPLE OF DES MOINES

BABE BISIGNANO

Babe has certainly been a legendary figure on the Des Moines scene for the last half century. Everyone seemed to know where Babe's restaurant was on Sixth Avenue in downtown Des Moines.

Babe himself was always present to greet his guests. His colorful past made him a very engaging person to visit with. The Prohibition days, serving a little "time," being a professional wrestler. Everything added to the Babe mystique. And he received nationwide publicity when some celebrated actor who was appearing in a show at KRNT Theater liked Babe's great Italian food so much that he had it frozen and shipped to him in New York in future months.

I remember being at KRNT Theater one night with Anne for some production when, at intermission, someone came on stage to announce, "Babe's restaurant is on fire!" You could hear a gasp run through the audience. Fortunately, it was restored after the fire and was better than ever.

NOAH LACONA

As we visit about Babe's and the many fond memories, I must also mention Noah's Ark and Noah Lacona. A popular gathering spot through the

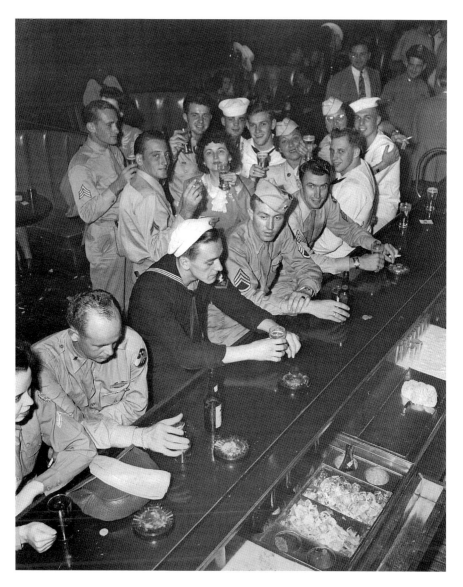

A crowd at Babe's.

years—and to this day—Noah's was one of our special family gathering spots. Those warm, fresh clover leaf rolls, that special salad and those super pizzas made a winning combination. All along, Noah Lacona himself would be there to greet you. And you can still find him once in a while, although his children have taken over. Did you know Noah was a race car fan and actually owned and raced his own machine? Of course, that was a few years ago.

Noah's was a special spot for those of us who were with Heritage Communications just down the street from the popular bistro. Jim Hoak and Jim Cownie were the two men who, at age twenty-eight, founded Heritage, which became the tenth-largest cable TV company in the country, thanks to the genius of these two remarkable young men. Those two men, myself and anyone else with us at the moment would walk the short block to Noah's many, many days for lunch. We always had a big round table, and it was usually full. What fond memories back in the late 1970s or early '80s.

Bill Jr. also has some memories of Noah that he was willing to share with us here:

Dad's good friend Noah Lacona is one of Des Moines' most colorful and loved personalities. Noah Lacona started working in the Des Moines area at the age of twenty-two, after being drafted in the army. He went to work for Beckman sheet metal and would have lunch at the restaurant at the Union Train Station across from the courthouse. Noah knew he could run the place better than the owner had been doing, so he purchased the restaurant. Back then, the average guest check was thirty-five cents! Noah and his wife, Sally, opened Noah's Ark in 1945. In fact, they opened the doors on New Year's Eve. The original location was the Union Train Station. This gave Noah a steady source of customers, and he even had a contract with the U.S. government to serve the troops as they were traveling. The original restaurant never closed and didn't even have a lock on the door! In 1948, Noah purchased a small building that is the current location, on Ingersoll Avenue across from the old Des Moines transit barn. The new location had eight barstools and one counter. Noah and Sally operated both locations until 1953, when the Union Station location was closed, leading to the first expansion and remodel. The Ingersoll location has been added on to or remodeled three times and recently survived a serious fire that would have closed other restaurants. Not Noah's. The family and staff took it in stride and reopened to the glee of everyone in the area. In fact, as I sat and listened to Noah tell me about the history of the operation, we were seated at the front table, right by the front counter. It was a thrill to watch Noah meet and greet his customers—or should I say family, because he treats everyone as family. Bill Wells, one of Noah's good friends, stopped to chat, and they had each other in tears as they traded jabs and jokes. Bill is in his nineties and has been coming to Noah's longer than most people. He is a perfect example of the relationship that Noah has built with his clientele through the years. I was amazed at how many people Noah knew by their first names and,

of course, always with a warm smile and a handshake. This is a man who really knows and values his customers. Noah's famous pasta dishes and pizza were family recipes that were passed down from Noah's mother. What some people don't know is that Noah has some of the best coffee in town. I think this goes back to the days of running the small restaurant at Union Station because, as Noah put it, "you only get one chance to show 'em what you've got, so you better do it right!" He told me that in business, "you have to have a hammer." Noah's "hammer" is coffee, pasta sauce, pizza, salad dressing and rolls. Oh, those rolls! The coffee is Noah's own blend and comes from San Francisco, as do the wonderful desserts. Another interesting story is the history of the revolving door at the restaurant. Years ago, Noah and his son Jim were staying at the Knickerbocker Hotel and were attending a food products show in Chicago in January. Jim and Noah noticed that although they were close to the front door of the hotel lobby and it was very cold outside, they were not feeling the wind due to the revolving hotel door. So, true to form, Noah asked where he could get a door like that. He tracked down a door salvage shop in Chicago and purchased the door that is on the restaurant now. The door is the original revolving door that was in the world-famous Palmer House in Chicago. Noah's has served food to Hollywood stars, as well as presidents and politicians. But some people don't know that Noah raced cars for many years; he even raced against Paul Newman! Noah was in the SCCA "A" sports racing class and was invited to race with the top amateur drivers in the country at Road Atlanta in Georgia. He finished racing in 1976 but still owns five race cars. He also has three German shepherds named Mouser, Rotti and Lola—all race car names. Thanks to Noah and his family for letting us peek into this amazing man's life and his passion for Des Moines.

THE IOWA
STATE FAIR FAMILY

Family is an overused word, but when it comes to Iowa State Fair employees, it is the only way to define the close relationship of the troop of dedicated people who band together to make the greatest fair in all the land a reality each year. It is impossible to try to mention even a small number of these dedicated people, so I have narrowed the field dramatically.

KEN FULK

Although the Iowa State Fair Board is responsible for major decisions and operations of the fair, the secretary manager is the chief executive officer in charge. My first secretary was Lloyd Cunningham, who in 1960 approved my bringing the *Talent Search* to the fair. Mr. Cunningham was a very large man but certainly was easy for me to work with. Next was Ken Fulk. What a character, what a gentleman, what a friend. Kenny was a dynamo, an ex-marine; whenever he was around, you were aware of his presence. I have mentioned earlier that Kenny made it possible for me to conduct the fifty-mile bike marathons at the state fair; he rode in those marathons, all fifty miles, on his old single-speed bike. Whenever people associated with the fair gather and Ken Fulk's name comes up, the stories literally pour forth. Everyone who knew him would have a Kenny story. Through the years, I had a bunch of them.

Bill with Ken Fulk at the Iowa State Fair.

One in particular comes to mind. It was opening day of the state fair—10:00 a.m. on a beautiful August day. We were at the concourse stage in front of the grandstand building to officially open the fair. The fair was dedicated to an Iowa admiral that year, and he was there to be honored. I called the crowd around and introduced Ken Fulk, fair secretary. Kenny came up behind me off-mic and said, "Keep talking, I forgot the admiral's flag." With that, Kenny jumped into his golf cart and drove up the middle of the concourse. Finally, after some time, here he came again, down the concourse with a huge flag he was to present to the admiral.

Ken was wonderful to me and was always doing something special to help the *Talent Search*. A memory I will always have of Ken is looking down a crowded, packed street at the fair and seeing him coming through the crowd. A great, tall man, Ken had a walking style that you can describe only as remarkable. You could always spot Kenny a block away. He went on to be head of the Orange County Fair in California. My wife, Anne, and Ken were also great friends. As a matter of fact, Ken appointed Anne to coordinate acts to appear on the free stages around the fair. Anne handled this task for three or four years. Ken was most persuasive, as Anne handled

this job with no thought of any compensation. She, like most Iowans, really loved the fair and enjoyed being part of it. Anne brought belly dancers to the fair one year and scheduled a top rock group, Westminster, from the Fort Dodge area for the first such appearance on one of the stages. Anne always laughs when we visit about Ken, as she remembers being on her hands and knees painting bright yellow stripes down the concourse for children's races. We miss him so much.

MARION LUCAS AND GARY SLATER

After Ken Fulk came Marion Lucas. Possessing a completely different management style, Marion Lucas will be remembered as the secretary who led the drive to completely renovate the fairgrounds. A fine administrator, Marion, again, was most supportive of the *Talent Search* and presided over the construction of the wonderful stage that now showcases the talented youngsters of the state. When the board hired Marion Lucas, it didn't know it had also hired his wife, Fran, who pitched in and contributed mightily to the success of the fair during Marion's tenure. Fran set up the Iowa State Volunteers group, several hundred volunteers who, to this day, act as information dispensers at each fair. What a wonderful idea this was and continues to be.

After Marion came our current manager, Gary Slater. Again, a different but very successful management style. Gary is consolidating all the changes and improvements and is presiding over some record-shattering state fairs. I first came in contact with Gary when I was a member of the fair board. We hired Gary to act in the special events department of the fair, including all the interim events most people don't realize are being conducted at the state fairgrounds almost every other week of the year. Gary handled this important job very well and was a logical appointment to succeed Marion Lucas when Marion retired.

JOHN PUTNEY

Although not a secretary-manager of the fair, John Putney has played an important role in refurbishing the fairgrounds during the past ten years. When I was serving on the fair board some years ago, I accepted the

assignment of director of the Blue Ribbon Foundation, designed to bring the fairgrounds back from its deteriorating condition. My intentions were good, and I tried to raise funds. One year, I set up a lottery with a big family trip as the award. After the run of the fair, we had more than $20,000 for the fund. But that was peanuts—we needed millions. For instance, the roof on the swine barn was more than $1 million. So we agreed it must be headed by an aid director. One day, Marion Lucas called me in his office and said he had found the man for the job in John Putney, who was from a great Iowa family with roots as fair exhibitors through the years. What a stroke of genius to land John as our new director of the Blue Ribbon Foundation. I happily transferred the duties to John, and he took off like a whirlwind. He had spent years as special assistant to Iowa senator Chuck Grassley, so John knew the workings of the Iowa legislature and tapped that source. Well, the evidence of his success is everywhere you go on the grounds today, whether it be a bench someone donated funds for, refurbished buildings or the wonderful new state fair museum. Where I was knocking myself out to raise a few thousand dollars, John Putney has raised millions for our fair. John will be the first to shy away from credit and always thanks the Iowa legislature and the thousands of Iowans who teamed up to rebuild the fairgrounds.

LEE KLINE

As we visit about folks along the way, I want to include one person who spent most every day—all day long—at the state fair for several decades, just like I did. We seldom saw each other and would hardly recognize each other if we passed on a busy state fair sidewalk. The person? Lee Kline of WHO Radio. The reason? He would spend each hour of every day at the true heart of the fair: the animal show rings. While Lee was there, I was a couple blocks away on my show stage with the young folks in competition. But I thought it would be very nice to visit a bit about Lee and his many accomplishments in the farm department of WHO Radio (just like my dear friend who served at WHO before Lee, Herb Plambeck). Another reason for mentioning Lee Kline is for his magnificent contribution in preserving stories of the past decades in Iowa with his super audio tape series called "Lee Kline's Iowa Notebook." This is a whole series of at least five CDs of stories Lee has collected for the past thirty years or so. Now, I was not raised on a farm, but I love listening to these stories, and I am so impressed with Lee, as the

profits go to support our wonderful Living History Farms. I might mention that the "Iowa Notebook" makes a super enjoyable gift, which, by the way, my daughters gave me last Christmas. Among all the delightful stories that Lee collected as he traveled the state with his trusty tape recorder is one of a farmer who sings in a trio. The only thing is, the other two members of the trio are pigs! That's right, good old Iowa porkers. You have to hear them to appreciate them. At any rate, we salute Lee Kline and his magnificent effort to preserve memories of the past, just like we are trying to do a bit in this book. Maybe the farmer and the pigs could appear on the Grandstand Stage. They could be billed as the Three Chops!

Don Greiman

One of the most difficult assignments for me would be to try to write a bit about one specific state fair board member because I have known many, and each brings a certain dedication to the position. I know because I served as an elected member of that board for about ten years before my retirement.

One name comes to the forefront every time, and that would be Don Greiman of Garner, Iowa. Why? Because Don has established a most remarkable record of forty years as a state fair board member. I don't think that way back through the years anyone has even approached that most remarkable record of service to the people of Iowa. One current board member, Dave Huinker, of the Decorah area, is probably closest to Don's remarkable record, with some twenty-five years of service.

I first met Don Greiman many years ago as a most engaging, enthusiastic young board member. I had already been tramping around the grounds for many years, and this new board member was immediately eager to learn all he could about the fair. We became friends from the start and have remained so through all these years, particularly when I was on the board with Don. The remarkable thing about Don Greiman is his boundless energy. While giving his all for the fair, he has been one of the number one boosters of the Iowa State University alumni. His Iowa State license plate backs up that dedication; it is simply "TRU FAN." There is really not a better way to describe Don Greiman than as a true fan of all he embraces. While doing all these things, Don also managed to be a member of the North Iowa Fair Board for many years.

There are few people in northern Iowa who do not know Don Greiman, and I'm sure many of those folks joined me in urging Don to run for political

office, even U.S. Congress, but we never could convince him to take the political plunge.

We cannot visit about Don Greiman without mentioning his delightful wife and good friend, Yvonne. With a husband going full blast, juggling several projects at the same time, all the time, only Yvonne could have placidly been part of the saga of Don Greiman.

DUFFY LYON AND THE BUTTER COWS

If a survey was taken and the question asked was to name the principal attraction of the Iowa State Fair, the winner would be, hands down, the butter cow! People not familiar with our fair would think we were nuts, but the creative magic of Duffy Lyon has captivated us all through the years. During the 2004 fair, a young reporter from the Dallas, Texas morning news did an interview with me. She just couldn't understand why more than one in every three Iowans chooses to visit the fair each year. Well, I told her it was tradition and a cow: a butter cow! I really wasn't kidding because I think the butter cow (and other Duffy Lyon creations each year) act like a catalyst. When you ask what people like to see at the fair, you'll always get the cow as one answer.

FLOYD AND HELEN DEETS

Even a dyed-in-the-wool fairgoer might not recognize the names of Floyd and Helen Deets, but these two have played a major role in operating our fair through the past decades. For years, Floyd was grounds manager of the fair, and the Deetses actually lived on the grounds all year long. Although we all enjoy the fair once a year, the fairgrounds are like a small city that functions 365 days a year. With the refurbished buildings on the grounds being winterized in greater numbers, that activity is literally all year long. Although I knew the Deetses through the years, I became so impressed with them in retirement; they continued being dedicated to the fair and operated the old historical museum as a labor of love. They exhibited and housed our Hey Bob dummy for two years until the old dummy found a permanent home in the new Iowa Falls Historical Museum. Floyd once cornered me

and said, "I've found one of your drawers." It took me a moment to remember that through the many years of the fair, I didn't have an office (I was out on the stages all the time). So I would just be assigned a desk somewhere to keep my papers. And it usually was a different desk each year. Well, I got in the habit of signing the bottom of one of the desk drawers with the information about that particular year. I did this for maybe ten years, and Floyd and Helen Deets had discovered one of those old desks that had found its way up to the museum. What a treat it was to read my inscription. And I wonder where a few more of those desks might be today. We salute Floyd and Helen Deets, who have literally dedicated their lives to our grand lady: the great Iowa State Fair!

JAN HIGGINS

Jan started in with the fair some thirty years ago as a bookkeeper and rose through management to end up as assistant director of the fair for the past several years. In her quiet way, Jan was great at diffusing the many problems that would pop up on an almost daily, or maybe I should say hourly, basis. Always offering a genuine smile, Jan Higgins's office door was always open, and she always had time to visit, if only for a moment. As assistant fair director, Jan would take the pressure off the manager and keep the great Iowa State Fair machine purring like a well-tuned engine. On any given day, you could find Jan anywhere on the grounds, always working to make things run even more smoothly.

KATHIE SWIFT

Talk about a tough job. Few realize that as publicity director, Kathie Swift was always being asked to answer questions about the fair. Just like the press secretary of a politician's staff, Kathie was the spokeswoman for the fair for many years, and she did her job so well. It is impossible to describe the day-to-day pressure of her position. It seems there is a crisis (in someone's mind) every hour of every day, and Kathie, in her delightful, calm way, would manage to work things out. Another big job for the publicity director is to coordinate the visits of hundreds of newspaper, radio and television reporters who report on the fair in the course of a year. I always loved to visit

Kathie's office and did it at least once each year, but only for a few minutes. It was fun to witness this smiling, calm person always doing about three things at the same time.

ZAGNOLI BROTHERS

Two of my favorite concessionaires through the many years would be the Zagnoli brothers. Remember ZAG's Popcorn stands? Well, the Zagnolis have been at the fair for years and years. I used to enjoy seeing Mr. Zagnoli as I rushed from stage to stage. I always marveled that Mr. Zagnoli would seem to be everywhere; I used to literally see him coming and going. It was not until many years had passed that someone, one day, said something about the Zagnoli brothers. And suddenly I realized that for years I had been visiting each day with the Zagnoli brothers—the Zagnoli identical twin brothers! I could hardly believe it. I must make a specific mention of these warm, wonderful men and our bicycle marathons at the fairgrounds back in 1970–72. The Zagnolis opened a stand each marathon Sunday and provided drinks for the riders and popcorn for the spectators. The Zag brothers were truly the spirit of the fair through the years.

SHI FOUNDRY

Speaking of the spirit of the fair, certainly the spirit of the grandstand through the decades has been Shi Foundry, a big, wonderful guy. Everyone is a friend to Shi. I used to love going into the concession stand in the grandstand and pouring beer for Shi and his fun-loving crew. I'll confess, it takes no talent to pour beer on a sweltering August night at the grandstand with an attraction like the Rock-and-Roll Reunion. All I would do is line up a whole fleet of glasses, turn on the beer spigot and push the glasses one by one under the cold, bubbly stream. I would never turn off the spigot! I met Shi in Des Moines before meeting him at the fair. I was serving on the Des Moines Park and Recreation Commission, and Shi came before us each year to be awarded the concession contract at some of the Des Moines swimming pools. Again, never a problem, always the businessman, always the gentleman—Shi Foundry.

CARL CARDAMON

Here is a wonderful story about the "Gizmo King" that stretches all the way from the present day back to 1946, the year KRNT Radio brought TV to Iowa and the exact year an enterprising young man named Carl Cardamon opened his concession stand at the Iowa State Fair. Carl and his family have operated in the same spot on the fairgrounds for the past sixty years. Although we did not know each other back then, we soon became friends when I started to do the talent shows in the plaza area. Actually, our one stage just off the Administration Building steps was practically in Carl's little patio by his stand. As the years and, yes, decades went by, Carl and I became good state fair friends, seeing each other only once a year at fair time. Many are the visits Carl and I would have in the shade of his little patio. During the last few years, our annual visits became limited, as Carl was fighting cancer, and his daughter and son-in-law, Carla and Kirby Wood, had taken over the work of the stand. But Carl was always upbeat, and we made a firm pact to be together each year until 2006. Well, darn it, Carl will miss our visit at the 2006 fair, as he fell victim to cancer just a couple years ago. But Carl knows I will trudge from the stage across the plaza grounds to his popular food stand. It will be a bit of an effort for me to make it this time—but Carl, I'll be there. I'll sit in one of your special chairs, have a Coca-Cola and just let sixty years of memories wash over this emotional old Irishman. By the way, I will have my traditional sandwich as I wallow in those memories of you and me. What sandwich will I have? Why, a famous Carl Cardamon GIZMO, of course!

DEAN DAVIS

One exhibitor we have mentioned before is Dean Davis and his wife, Jaci. Dean's main mission at the Iowa State Fair, and for some thirty years, was operating the turquoise jewelry stand at the extreme outside corner at the northeast end of the Varied Industries Building. We met Dean in Clear Lake years ago while he was having a jewelry exhibit. I asked if he would ever consider exhibiting at the state fair. At first, he pooh-poohed the idea, but Anne and I kept on him and even offered him lodging at our home in Des Moines if he would come (staying with the Rileys and their five children during fair time is no small feat in itself). Well, they came, and as so many have found through the years, the Iowa Sate Fair is a truly magical place. And, yes, Dean and Jaci have come back each year for three decades.

Lynsie's Exhibit at the Fair

Over the years, Bill Jr. and I have come in contact with hundreds—no, thousands—of wonderfully talented youngsters. I wanted to highlight an act but could not focus on one until I found out about Lynsie Sievertsen and her 2006 4-H exhibit at the state fair. Lynsie poured several hundred hours of work into her special display by creating a miniature model of the Bill Riley Stage. Her project outlined the *Talent Search*. Lynsie has been in competition at the state fair herself and became interested in how it got started.

So to all of the special Iowa youngsters, thank you for making the *Talent Search* an incredible success! Here is a note from Lynsie about her project:

When my sixth grade social studies teacher gave my class the assignment of doing an Iowa history project on something important in the history of Iowa, I immediately chose the Bill Riley Talent Shows *and the life of* Bill Riley. Bill Riley Talent Shows *have been a part of my life for as long as I can remember. I have been going to the Iowa State Fair since the year I was born. My mom says that from about the time I was four, I would have to go to the Riley Stage at noon to sit on the cement at the front of the Riley Stage and watch the performers. That's probably when I set the goal for myself that someday I would perform on that stage. I first did that in 2002, doing a tap dance routine with my cousin Josh to "Great Balls of Fire." Josh was nine, and I was eight. My mom said it was a moment to remember because we had performed in nine local shows that summer, and it wasn't until the seventh one that we even placed and qualified to perform at the state fair. We didn't advance at the state fair, but it didn't matter because it was just so cool that we got that far. After that first year, I had to go back, and I have been for the last four years. In 2003, Josh and I did a jazz dance. We were in nine local shows again, but this time, the second show we were in, we won first place and qualified. At the state fair, we also advanced to the semi-final round. We weren't one of the six sprout champion acts, but we automatically qualified for the next year, and we were excited. In 2004, Josh and I did a jazz dance to "I Like It Like That." We performed in eight local shows and placed in six of them. It was a great year. At the state fair we did well, but we didn't advance. In 2005, Josh and I were asked to join two kids from Denison who had also been doing Bill Riley shows for a couple of years. We formed a gymnastics quartet. We were lucky and qualified for the state fair in our first local show. At the state fair, we advanced to the semi-final round. This year I*

am in another gymnastic quartet. *The two boys from last year are in my group and a new girl from Vail. This will be my last year performing as a sprout. I'm not sure what I'll do next year, but I do know that I'm not ready to quit yet. I'd like to continue being in* Bill Riley Talent Shows *and continue to be a part of a long tradition at the Iowa State Fair. The Bill Riley shows have been lots of fun, and by being in the local shows, I have been able to see lots of Iowa. In the last five years, I have been in a total of thirty-eight local talent shows in twenty-four different towns in Iowa. The Bill Riley shows have made lots of great memories for me. So when I heard about the Iowa history project, I had to do...my topic had to be* Bill Riley Talent Shows *and Bill Riley. After reading Bill Riley's book* On Stage *and reading the information on the KRNT website about Bill's early history in radio and TV, I learned that Bill Riley truly is an important part of Iowa's history.*

17

FAMOUS PEOPLE

RONALD REAGAN

"Dutch," as we knew him back in the 1930s, played an important role in my life. Carl Hamilton, to whom I referred earlier as my mentor (the man who was editor of the *Iowa Falls Times-Citizen*), gave me my first job as a junior in high school and guided me throughout those early years. But the Dutch Reagan era came even earlier.

As a boy of about fourteen or fifteen, I visited the Iowa State Fair alone and found myself on a bench in the extreme northeast corner of the big Varied Industries Building. There, in the "Crystal Studios of WHO Radio," was the young sports announcer, Ronald Reagan, re-creating a Chicago Cubs baseball game from a little ticker tape giving him the information. From the wisp of paper, he would use words to describe the ballgame, the batter, the crowd and the weather. He truly made it live, complete with tapping the mic when someone would get a hit. He would then say, "There it goes…back… back…it's over the fence…a home run!" I was truly spellbound. I thought if only someday I could be a sports announcer and be at the state fair, on stage or on mic!

Well, little did I know that that would really start me on a career of sixty years of radio and state fairs.

JOHNNY CARSON

Did you know that Johnny Carson, who died in January 2005, once visited the Iowa State Fair? It was probably in the early 1960s, when Johnny left television in Omaha and was selected to go to New York for the *Tonight Show*. I was asked to meet Johnny's plane at the Des Moines Airport and drive him to the KRNT Radio studios on the fairgrounds for an interview with newsman Russ Van Dyke. It was an exciting assignment, and I found that Mr. Carson was not much younger than I and was a most happy, entertaining person.

ROGER WILLIAMS

One of my favorites through the years has been Roger Williams, or Louie Wertz, as we all knew him in the good old days of KRNT Radio. After gaining international fame, Louie changed his name to Roger Williams.

I first met Roger when he was a student at Drake. I was just beginning at KRNT Radio. I heard folks talking about a young Drake music student who used to come to the big main KRNT studio in the afternoons to play our beautiful baby grand piano. I found out that he was the son of the popular Reverend Wertz, whose church was located in the downtown area. At any rate, this student would come in the late afternoon after the *Gene Emerald Show*, when the studio would be free. He would play and literally make that big piano sing. We would cluster around and enjoy those impromptu concerts. Little did we know, we were being entertained by a person who, in later years, was to become internationally acclaimed. By the way, Roger signed that piano in the string area. I wonder where that piano is today— and does it still bear the signature of the budding virtuoso?

The last time I saw Louie was at the state fairgrounds in 1986. Louie had come home to Iowa for the Homecoming '86 promotion we were conducting for Governor Terry Branstad. We had a wonderful hug, and I said, "What name do I use?" He said, "Either one...just think of Louie Wertz as my maiden name." Roger (we'll call him Roger from now on) was the main former Iowan to return and help our celebration.

In the summer of 2004, Roger visited with Babe Bisignano on the phone and then played several songs for the delighted Babe to enjoy. How about that? A personal concert by the famous Roger Williams! Babe loved it (who

wouldn't?). You see, Roger played at Babe's famous restaurant for a couple of war years, when Babe's was headquarters for women of the WAAC training at the Des Moines Army Post. It is interesting to know that many training flights by the U.S. Army Air Corps ended up in Des Moines for weekend layovers. I wonder why? Was it Roger Williams or the WAACs?

CLORIS LEACHMAN

I first had the privilege of knowing Cloris Leachman as we all got together to read the *Sunday Funnies* on KRNT Radio. Probably about Thursday of each week, we would get the advance copy of the *Des Moines Register* "Sunday Funnies." This was a super fun time, as everyone who was free would come to the "big" studio and would take the parts of the characters in the Sunday funny strips.

Cloris Leachman was chosen by our program department to come in for these sessions. The reason for the choice was obvious. Cloris had a wild and wonderful manner about her. She could take any part in the funnies and make everyone roar with laughter; she made each session a fun event.

At the time, Cloris was a senior at Roosevelt High in Des Moines and would rush down after school to join me in reading the funnies. I can see her now, bursting out of the elevator, on the thirteenth floor of the Register and Tribune Building, slipping into a chair across from me and then ripping through the funnies, using the wildest and most wonderful voices you could imagine. Suddenly, our fifteen minutes was over, and she was gone. Wow, would I love to be able to hear one of those shows again!

By the way, did you know Cloris Leachman came very close to being Miss America? While a student at Northwestern, she entered from the Chicago area. Of course, you must know that she won an Oscar and has for years been a celebrated Hollywood actress. What a pleasure it was to have met Cloris Leachman along the way. What a beautiful, fun-loving person!

GORDON GAMMACK

Gordon was very special to all who knew him. He was a popular columnist at the *Des Moines Evening Tribune* for many years and also a celebrated war

correspondent. It seemed he was always in some wild and exciting place filing his stories. Gordon lost the sight in one eye in the course of his many exciting assignments.

I became friends with him when he was selected to read the 6:00 p.m. news on KRNT Radio each weeknight. As it so happened, I was the board announcer for many of those nights, so we had a chance to enjoy each other's company while waiting for news time.

There is one of Gordon's columns I would surely like to see again more than sixty years later. A column that included mentioning his announcer and the fact that I was engaged to "one of the prettiest girls in all Des Moines." I agreed then, and still do, as that "pretty girl" was Anne Riley!

Betty Wells

KRNT Radio pioneered the featuring of female directors on the air. When I came on board in the mid- to late 1940s, Betty Wells was the on-air personality, and she was dashing and flamboyant, a true personality. Betty was a book reviewer of national acclaim. My office was down the hall from hers, and it seemed she would receive a shipment of books every few days.

Well, Betty was a staunch Christian Scientist and would have nothing to do with any books of a medical nature. As a result, she gave me all books of such content. Anne and I had a large bookcase along one wall in our house in Des Moines that was filled with one of the finest medical libraries in town.

Betty Wells went on to the Minneapolis market, and I lost track of her. We sure were the best of friends.

Elizabeth Clarkson Zwart

Following Betty Wells was another person I enjoyed very much. Her name was Elizabeth Clarkson Zwart. I believe her nickname was "Beanie." She was a popular columnist for the *Des Moines Register*, and as with columnist Gordon Gammack, management ordained that Beanie should have her own radio show.

I always enjoyed being "on the board" as the announcer on mornings when Elizabeth was on the air. She was bubbly and I'm sure very popular.

MARIA VON TRAPP

I remember one morning when Elizabeth Clarkson Zwart was not available for her show, and I had to sub for her. Her guest that day was Maria von Trapp, of the internationally acclaimed von Trapp Family Singers. They were in town for a concert. Everyone knew of the family and their escape from Hitler's troops. Well, that morning I was so very excited to be interviewing this world-famous person. She was a delight, and we had a great visit. A week after our interview, Maria gave birth to a baby boy. Many years later—like forty or so—Anne and I were traveling in Europe, and our luncheon stop one day was to enjoy the von Trapp Family Restaurant somewhere in the Bavarian Alps. I found out that the boy Maria was carrying the day of our interview was, indeed, the manager of the restaurant. And when I asked about Maria's fate, I found out that she was buried on a beautiful knoll up beyond the restaurant.

MEREDITH WILLSON

One guest was particularly special and was on Mary Jane Chinn Odell's show several times. It was Meredith Willson, Iowa's own musical genius. We had great visits. Meredith was a true Iowan—warm, friendly and most unassuming. One thing did bother Meredith, and that was the "Iowa Corn Song." He hated that song as our designated state song.

I remember he groused particularly about singing "Ioway" instead of Iowa. So what did he do? He wrote a song. I hope you get to hear it sometime. It goes: "Iowa. It's a beautiful name when you say it like we say it back home." A truly lovely melody.

When my wife, Anne, and I were honored in Mason City in May 2003 at Music Man Square as recipients of the Meredith Willson Heritage Award, I appealed to our state leaders to consider keeping the "Iowa Corn Song" as the Iowa pop song but to adopt Meredith's beautiful "Iowa" as our official song. But no luck. I still think our state should recognize the Iowa Music Man with such an action. Maybe, just maybe, Iowa will recognize one of its most famous sons, Meredith Willson of Mason City—our very own Music Man!

ROSEMARY WILLSON

Another delightful person I met along the way was Rosemary Willson, Meredith's widow. She has been a great friend of our state. In 1986, then-governor Terry Branstad named me and Mary Jane Chinn Odell as co-chairs of his Homecoming '86 plan to promote Iowa. One of the first things we did was to contact Rosemary Willson to ask her permission to use Meredith's wonderful song "Iowa." Rosemary responded right away, not only saying she was pleased, but also granting permission without any copyright charges. And to top it off, Rosemary agreed to come back to Iowa in August 1986 for our big homecoming finale program from the Grandstand Stage of the Iowa State Fair. I acted as Rosemary's escort for the program. We sat together, and then I escorted her on stage as she was introduced.

We still laugh about that night, as it was threatening rain and Rosemary came armed with a large umbrella just in case. I assured her it would not rain (as if I would know). But it did not start to sprinkle until we were through with the program—how fortunate we were.

My next meeting with Rosemary Willson was on May 30, 2003, when Anne and I were honored in Mason City at the Music Man Square, where we received the Meredith Willson Heritage Award. What a thrill it was to find Rosemary Willson had come from California to be with Anne and me that night.

Speaking of Music Man Square, the residents of the Mason City–Clear Lake area are to be congratulated for creating this replica of the Music Man city (River City) from the movie *The Music Man*. It is a true delight; be sure to pay a visit. In the complex is a very fine, and popular, meeting hall, and the upstairs rooms are set aside for music instructors to teach their classes (just like in the movie). Truly a little Music Man city dedicated to the Music Man himself, Meredith Willson.

Needless to say, Rosemary Willson played a vital role in bringing this wonderful dream to fruition in the form of a huge donation. I want to say thank you to Rosemary Willson for being a friend, not just of Anne and me, but a true friend of Iowa.

SIMON ESTES

What a most unusual association this has been through fifty years. It started way back in the 1950s with a talent show in Centerville, Iowa. Strangely, I remember that very evening. I had never done a show in that fine city, so I was excited. I remember driving into Centerville in the early evening and finding the parking lot full. Wow, what a surprise—until I found the crowd was there for a baseball game. Calmed a bit, I went in for the show and had found I still had a very nice crowd.

The highlight of the show was a fine youngster who was twelve years old and sang "Little Jesus Boy." As I listened to this soaring soprano voice, I knew I was going to put him on television without a doubt.

Of course, I did. There was no state fair show at the time, so Simon never appeared in competition at the fair. However, he was wonderful and was on the *Teen Time* show as a sprout. I gave him a large stuffed animal as a gift for appearing. Remember it, Simon?

As time passed, our lives drifted apart. Simon went on to achieve great success as an internationally acclaimed bass baritone opera star. I saw Simon again in Washington, D.C., when we both supported Chuck Offenberger's

Anne and Bill Riley with accompanist Barb Cortesio and Simon Estes.

Simon Estes honoring Bill at his Iowa State Fair retirement celebration.

bike ride across America. "The Iowa Boy" had organized the ride to commemorate 150 years of Iowa statehood.

Our next meeting came at the state fair in 1996 for my retirement from the fair. Simon was there! He had flown from Frankfurt, Germany, where he was appearing (it was a twofold trip—he came to see his sweet mom, too). This day will never be erased from my memory. Great, wonderful Simon Estes giving his friend Bill a personal concert before some five thousand people jammed into the plaza area. Marion Lucas, fair director, said he had never experienced the fair audience so completely still.

Simon sang my request for "Old Man River" with his accompanist from the Centerville show, Barbara Cortesio. Then he turned and stood in front of me, some twenty feet away, and said in his gorgeous voice, "Bill, you and I have both had our share of mountains to climb during our lives, and this one is for you." With that, he sang "Climb Every Mountain" and had me crying as only an emotional Irishman can. It was the moment of a lifetime!

Our next meeting came on May 30, 2003, when Simon came to Mason City to bestow the Meredith Willson Heritage Award on Anne and me. Again, it was electric. As Simon engulfed me in a huge hug, I thought, "This great man has played an exciting role in my life."

18

LETTERS

These fine people were good enough to write letters to share their stories of our time together. Thank you to each and every one of you for letting us include your memories in this book.

JULIE GAMMACK, DAUGHTER OF GORDON GAMMACK

I didn't realize the extent of Dad's on-air insecurities and suspect by the time I came along (born in 1950) they had lessened. I do remember one family story about when Dad was booked to give a talk at the KRNT Theater after returning from a stint covering Iowans serving with the Thirty-fourth Division in World War II. This was before my time, but the story is kind of funny.

Days before the event, my mom was sure no one would show up, so she got on the phone and called her friends, promising that if they'd go to the speech they could come over to the house afterward for dinner. The evening arrived, and as Mom and Dad pulled onto High Street, they saw cars parked all over. They wondered what must be going on that there'd be so much traffic in downtown Des Moines. The hall was packed with folks who'd followed Dad's coverage of the war and had come to hear what he had to say in person!

Dad used to take me down to the old KRNT studio when he recorded his Sunday night talk show. In the early days, they did the shows live at 10:20

p.m., but that was past my bedtime. When tape was invented, that meant I could come downtown with him on Sunday evenings as the show would be prerecorded. I'd sit in the control booth with director Hersh Weekly (who was very cool) and watch the action. Russ Van Dyke would be doing the weather on that Plexiglas map thing in the studio on the left of the booth, then they'd switch to Pat Valentine doing the Corwin Cleaners commercials, then to Gordon Gammack and guests.

Bill Riley shared an office at KRNT with Mary Jane Chinn Odell. Mary Jane's daughter Chris and I were pals and hung out together. It was fun to be able to see the piles of kid stuff that were a part of the *Bill Riley Show*.

I have very special memories of the old KRNT studios…the long, black-ribbed linoleum hallway from the back entrance to the receptionist's desk, being "buzzed in" for security purposes—and this was when security precautions were rare, so it seemed quite impressive to be let in—the cameraman (Bobby? What was his last name?)…Maury Chicoine, the still photographer, the women's restroom that had big, bright dressing room light bulbs surrounding the mirrors.

As for Bill Riley, he was and is to this day an Iowa icon, embodying what we hold as a part of the state's personality—kind, family-oriented. The judges on today's popular show *American Idol* could learn a thing or two from Bill Riley about how to treat folks at a talent contest.

In my days as a talk show host on WHO Radio in the 1980s, I remember being worn out by the heat, the crowds and the responsibility of doing a live show from the Iowa State Fair. I would be exhausted after just a three-hour shift, and Bill Riley would just be getting started, organizing the kids at the stage nearby and managing all of the logistics of putting on daily shows. Where did he get his energy?

GUY KOENIGSBERGER II

Let it be known, Bill Riley kept me at KRNT Radio. I got there by myself, but Bill helped keep me there. After graduating from the University of Washington and going through an intensive television workshop in New York City, I was hired as a copywriter at KRNT late in 1949. I'd already read characters at the station while in high school, taken broadcasting courses at Drake and knew some of the powers that be at the station. They assured me

it was only going to be a short time until KRNT was granted a TV license and would be the TV affiliate of CBS in central Iowa.

As it turned out, the owner of KSO Radio, Kingsley Murphy, challenged Mike Cowles, owner of KRNT and the *Des Moines Register and Tribune*, for the coveted FCC license. It wasn't granted by the commission for five years.

These were very frustrating days for me and all the others who were sweating it out in radio, just waiting for their big opportunity to move into the new and exciting medium of TV.

Although I was somewhat involved in preparing proposals and program descriptions for our attorneys in Washington, D.C., it was still a daily routine of nine to five, writing commercials and producing spot announcements. I seriously considered, and made some inquiry, into finding employment at another radio station that had just received a TV license.

Then along came Bill Riley. He'd decided his big *Hey Bob* safety show needed a colorful clown to add some fun to the live stage shows every Saturday morning at the Paramount Theater. Although I'd never considered running away to join a circus, the thought of devising my own clown character and putting my creative juices to work in a visual and performing direction was intriguing. And so, Ko-Ko the Klown was born. It was a ball! Just a few of my memories:

- Doing the regular warm-up show for which I went down in the orchestra pit to play the piano and sing songs I wrote, such as "The Hey Bob Boogie," "Ko-Ko's Question Song" and "You ARE a Hey Bob!" They all had to do with safety reminders.
- Meeting national celebrities whom Bill talked into making appearances when they came to town. The zany band leader Spike Jones told Bill that he thought I was the cleanest clown he'd ever seen. Not the funniest, just the cleanest, but I always appreciated the comment.
- Doing the show periodically in the 4,200-seat KRNT Theater, particularly when the ice-skating show was there. Our general manager was in the wings, and he was certain I was going to break an arm or leg. He didn't know I'd spent hours skating at the Greenwood Park pond as a kid.
- At another show at KRNT Theater, my wife, in her clown makeup, and I roamed all over the audience trying to find each other while disappearing behind the curtain and giant pillars. Backstage, though, Bob Crosby, the noted band leader and brother of Bing, pinched her bottom. Boy, did she have fun being incensed and lashing out at him in her schoolteacher voice.

- Two shows with the Ringling Bros. and Barnum & Bailey Circus under canvas at the fairgrounds. All the children yelled out my name during the walk-around, but they knew none of the greats, including Felix Adler, who at that time was more well known than Emmett Kelly. I even got to participate in the twelve clowns stuffed in a little car routine.
- Out-of-town *Hey Bob* shows. At one, I had to get dressed in the boys' locker room at the gym. It was quite a distance from the auditorium, and I had to make my way through the crowd that was still waiting to get in. A rather large boy made a memorable impression on me—a hard, swift knee to my groin! I hobbled to the stage as Bill opened the show.

My "Ko-Ko Adventure" made the months and years go more quickly. Each week, there were costumes to come up with, such as a cowboy outfit when the rodeo was in town or being a fireman during Fire Prevention Week. There were props to make—a heavy shot put from the Drake Relays that turned out to be a bouncing ball. It was more fun than a thirty-year-old should have. And besides, I made ten dollars every time I suited up to work with Bill.

By 1953, in order to give our radio staff hands-on experience with television and to show the FCC we were really serious, a large room in the basement of the KRNT Theater was converted into a small TV studio. Several nights a week we did commercials and tried out various program formats with our well-known radio personalities, Don Bell, Gene Emerald, Al Couppee, Paul Rhoades and Russ Van Dyke. We also auditioned outside talent for possible shows. Mary Jane Chinn was one.

I had to hang up the clown suit when we finally got on the air on July 31, 1955. Being production manager took a great amount of time, and of course, that is what I'd been waiting for. But I was still there—my goal had been reached, and it resulted in a lifetime career that I loved. I retired from TV8 (by then KCCI-TV) in 1989 and have always been most grateful that I stayed around for forty years.

Thank you, Bill. You made a big difference in my life.

"THE SAFETY BOOGIE"
By Guy Koenigsberger II
It's the Safety Boogie Play Safe! Safety Boogie Play Safe! Safety Boogie Play Safe—Play Safe—Play Safe—Wait on the Red—Go with the Green—Look Both Ways and Be on the Beam—It's the Safety Boogie Play Safe!

"YOU ARE A HEY BOB"
(Tune: "You Are My Sunshine")
Down at the corner…the traffic signal
Was plainly changing green to red
Along came Hey Bob…he tried to beat it
But a car hit him instead.

CHORUS:
You are a Hey Bob…a funny Hey Bob
The biggest dummy I ever knew
You're never careful…you're always careless
I don't want to be like you.

There were two cars parked…next to the curbing
From in between them came our friend
Now he was running…a truck was coming
And it knocked him on his end.

(REPEAT CHORUS)

Among some dry leaves…he lit some matches.
He liked to hear the crackling sound.
The wind got blowing…the fire got going
Hey Bob's house burned to the ground.

(REPEAT CHORUS)

Out on a bike ride…Hey Bob was sitting
Perched high up on the handlebar.
His pal was pumping…they lost their balance
And got thrown beneath a car.

(REPEAT CHORUS)

"Let's play some football!" ol' Hey Bob shouted.
So both teams lined up in the street.
A bus came toward them…and on the kickoff
Booted Hey Bob off his feet.

(REPEAT CHORUS)

"KO-KO'S QUESTION SONG"
Should you cross the street on a red-red light? (No-No, No-No)
But what can you do on a green-green light?
 (Go-Go, Go-Go)
And can you tell me what's my name?
 (Ko-Ko, Ko-Ko)

Yes, I'm Ko-Ko, the Klown
I'm Ko-Ko, the Klown
My suit is white, my suit is blue
My suit is red, and my nose is too
And the size of it is larger than TWO!
I'm Ko-Ko, the Klown!

What do you do with a needle and thread?
 (Sew-Sew, Sew-Sew)
What do you need if you want to bake
 Bread? (Dough-Dough, Dough-Dough)
And can you tell me what's my name?
 (Ko-Ko, Ko-Ko)

Yes, I'm Ko-Ko, the Klown
I'm Ko-Ko, the Klown
My pockets go down below my knees
My ruff comes up so my neck won't freeze
But my hat's small it flops in the breeze
I'm Ko-Ko, the Klown!

What comes down from a cold winter sky?
 (Snow-Snow, Snow-Snow)
What does a blackbird always cry?
 (Crow-Crow, Crow-Crow)
And can you tell me what's my name?
 (Ko-Ko, Ko-Ko)

Yes, I'm Ko-Ko, the Klown
I'm Ko-Ko, the Klown
I play piano or strum along
On my Ko-Ko-lin as I sing a song

And I sound just like Bing…(SING!)...or am
 I wrong?
I'm Ko-Ko, the Klown!

What do cats eyes do in the dark?
 (Glow-Glow, Glow-Glow)
What do flowers do in the park
 (Grow-Grow, Grow-Grow)
And can you tell me what's my name?
 (Ko-Ko, Ko-Ko)

Yes, I'm Ko-Ko, the Klown
I'm Ko-Ko, the Klown
I like to dance my funny way
I study magic every day
But the tricks don't work like the books
 Always say
I'm Ko-Ko, the Klown!
Yes, I'm Ko-Ko! (You're Ko-Ko!)
I'm Ko-Ko! (You're Ko-Ko!)
Yes, I am Ko-Ko, the Klown!

FLOOR DIRECTORS

Perhaps the most underrated of all the people who bring the magic of television to your home might well be the floor directors. These are the assistants to the directors and producers who are seated in the big control rooms. These are the young men and women you see standing by the cameras sometimes waving their arms madly to get the talent's attention.

Well, we have talked about the talent and the engineers with Bob Cannon. But just who would represent the floor directors? Well, it was remarkably easy to find just the spokesman for this group from the literally hundreds of young folks who helped through the years. I say hundreds because it is a perfect job for a college student who might be majoring in communications. As a result, we had lots of wonderful youngsters; many, I'm sure, have gone on to success in this wonderful medium called TV.

Who was this "easy choice?" Kevin Cooney, the current highly rated anchor on the Channel 8 News in Des Moines, came to us first as an Iowa State University student, and right away you could see he truly loved the field of TV. As a matter of fact, I still have a letter from Kevin from my KCCI retirement telling me how much he had truly loved working on my many shows throughout his years at ISU. I have that letter in an album today.

So I have asked Kevin to speak for those many, many super young folks and give us his memories of the days past. Oh, and I might as well admit, I'm darned proud of Kevin Cooney and his achievements. And what could be better than an Irishman named Riley choosing another Irishman named Cooney?

KEVIN COONEY

Yep, Bill, I was one of those floor directors you mentioned. What a great job for a high school or college student interested in broadcasting. I had the opportunity to be involved in virtually every facet of TV production. Floor directors helped directors, producers, engineers and every other department in the building. Therefore, we had contact with everything and anything having to do with the show. Sales, yep! News, of course! Sports, promotion photography, art—you got to know everyone and a little bit about a lot of things, which, as we all know, can be very dangerous. For everyone concerned. And Bill encouraged that creativity at every turn. Especially the *Breakfast Club*, which was taped every afternoon for playback the next morning. Floor directors like myself might suggest a theme for the day, or even the entire week. Once when Bill had a bike as a prize, I recall suggesting we have the floor directors in the background trying (unsuccessfully) to assemble the bike. As we taped, Bill would check in on us from time to time as we read instructions upside down, "inserting slot B in tab A" and generally assembling a bike backward. Not genius but fun.

As a matter of fact, it was on Bill's show, years earlier, that the "TV bug" first struck me. I was a Webelo Cub Scout in fourth grade at Holy Trinity School when we toured KRNT TV and appeared on Bill's afternoon show, *Variety Theater*. When Bill came to me and asked questions on air, I decided to talk about *all* our pets, which had died. (My mother was horrified and expected a visit from the ASPCA!)

But I remember on that same visit how a floor director was filmed hanging upside down while he was trying to drink some soda, which was spilling all over the floor. The picture was then electronically "flipped," making it look

like he was upright, and the soda, of course, was going "up." Seeing what was happening, and then how it looked on TV, got me hooked. "People get paid to do this?" I asked. I remember Bill telling me, the saucer-eyed Cub Scout, that they indeed *did* get paid, and they had a lot of fun, too. That was it. I was going to find some way to work in this business!

When I did, Bill was there to help and encourage us all. Sure, we would pilfer Archway cookies and Dodger Cola from his well-stocked office (these items were for his young "guests"— Cub Scouts like I used to be). We'd try to teach his Myna bird bad words, and we'd occasionally be a little late to the set, but Bill would remain firm and fun.

Rarely have most of us had the chance to know someone who truly enjoyed his or her job so much. I mean really loved it. I can't say for sure, but I think Bill is one of those people. There was always a smile, a story, a friendly pat on the back.

There are hundreds of stories that I could tell about incidents, funny and not-so-funny, that occurred while taping Bill's shows. (Or sometimes when we aired them live—no chance to correct errors when you're live!) But those times, while they'll be fondly remembered, won't be cherished like the memories of a true friend and colleague who helped you learn. And above that, a person who really helped to shape you into who you are today. Those are truly the memories I'll have forever.

These days, about the only local productions done by TV stations are newscasts. There are not many "kids shows" being done locally any more. Too bad. That means fewer chances for high school and college kids to learn how to build a background set for a *Talent Sprout* or come up with a theme or a week's worth of *Breakfast Clubs*. In other words, to be creative in local TV.

But it also means production assistants or floor directors or assistant directors most likely won't see and know the likes of a Bill Riley. A person who not only was on the show but also welcomed you on in some way as well. A person who says, "Let's try it" even when he knows this college kid's idea might not work (of course, that might be funnier than if it did!). A person who remains a friend forever.

Now Bill mentioned in a recent note to me that he'd like me to speak for those floor directors of the past. I'm not sure I'm worthy to speak on their behalf, but I know that as a starting place in TV, there's no better place than a studio production department. And for me, befriending the likes of Bill Riley guaranteed that whatever part of this business I decided to pursue, I was one step ahead of everyone else—and I'd have fun!

Thanks, Bill!

DAN MILLER

There's one phrase that comes to my mind when I think of Bill's time at Iowa Public Television: consummate professional. That's what he was.

Unlike some who look at a camera and only see themselves, Bill knew that it wasn't the reflection in the lens that mattered; it was the people on the other side of it. He had an absolutely uncanny sense of and rapport with his audience. And it was *his* audience, to be sure. He's the only person I've ever met who could actually make people telephone our *Festival* fundraising set as if by command.

I think that's because he respected his audience, and his audience respected him for it. He never stooped low for a laugh, never reached higher than he should. He focused instead squarely on the center—true to the traditions of Iowa and, in turn, establishing a tradition for Iowa Public Television.

We all learned from that. And we're all the better for it, too.

DON GRIEMAN

There is an old saying that states, "Time really flies when you're having fun." A truer statement couldn't be made of my forty-plus fabulous years serving on the Iowa State Fair Board. I attribute this to having the opportunity to be associated with so many wonderful and dedicated individuals who through the years have contributed so much to the success of the Iowa State Fair.

I wish I could recognize all these worthy people. I would be remiss, however, if I didn't acknowledge my mentor and dear friend, Mr. Iowa State Fair himself, Bill Riley Sr. This renowned radio and television personality has been such an inspiration and helpful not only to me but also to the many young people he touched with his talent contests. Of course, one of the more noted is Simon Estes.

When you think of Bill Riley, you also think of his beloved wife, Anne, or as her husband so affectionately calls her, "Annie." Bill will be the first to readily admit that Anne has played a very important role in his success and accomplishments.

Bill Riley traveling around the state of Iowa through the years, producing his talent contests, has been the state fair's greatest ambassador. Bill has refused any remuneration for his many years of service for his talent contest efforts.

The Bill Riley legacy continues to get bigger and bigger each year, and this year a record number of talent contests will be held. The Iowa State Fair is so fortunate to have Bill Riley Jr. continuing in his father's footsteps, and he has proved he is very capable of carrying on the Riley tradition.

In my years on the board, I've been privileged to witness and be a part of many changes. Everywhere you look, it is evident these changes have benefited the fair. Fair attendance has grown from about 500,000 in 1965 to over 1 million. This is remarkable when you consider the state's population is a little less than 3 million. This proves Iowans truly love and support their state fair. Fairgoers were allowed to park their cars almost anywhere on the grounds, and many still bring their own picnic lunches.

In the campground, many of the campers still sleep in tents. There were a few small campers making their appearance. The number of fairgoers camping has increased manyfold. The fair has become a very popular vacation destination for them.

There were only a couple permanent food concession stands, and the rest are what are known as "stick stands," or temporary tent structures. Presently, there are only a couple of tent food concessions stands, and the rest are permanent or portable. The quality and diversity of food items available to the fairgoer today are another reason they are attracted to the fair.

The girls' 4-H exhibits and demonstrations were held under the grandstand but had outgrown their space. About this time, a deadly poultry disease occurred in the state, causing all poultry flocks to be quarantined. As a result, poultry shows were cancelled for several years. It was decided to move the girls' 4-H exhibits and activities into the vacant poultry building and change the name to the 4-H Exhibits Building. It has made an excellent facility for the girls' 4-H activities. Incidentally, this building is heated and air conditioned and is the most used year-round facility on the fairgrounds complex.

When the poultry quarantine was lifted, poultry, rabbit and pigeon competitions moved to a new location on the east side of the fairgrounds, which was originally built as an employee dormitory but was seldom used.

The present Cultural Center was originally built as a girls' dormitory. As more and more families were camping or staying on the grounds, fewer girls were utilizing the dormitory.

The Iowa State Fair has always had an excellent reputation for its outstanding livestock shows. Changes in this area have also happened through the years. In the bee department, there were only four breeds, but in the last number of years, that number has expanded to fifteen. The draft horse show has always been strong, but in recent years this show is rapidly

becoming one of the premier state fair shows in the nation. The draft horse show is also becoming one of the favorite fair attractions, and huge crowds line the streets early to watch these magnificent animals as they make their way to the livestock pavilion to compete.

In the area of entertainment, there were two free stages; the main one was the stage now named the Bill Riley Stage. Because of the increased popularity of the free stage entertainment and the role it was playing in increased fair attendance and fairgoers camping for longer periods of time, the number of free stages and quality of entertainment increased.

The first several years of my being on the board, grandstand entertainment featured the same entertainment for the duration of the fair. Prior to afternoon and evening grandstand programs, a band played martial music as fairgoers located their seats. The band also played between heats at the afternoon horse races and for the nightly fireworks extravaganzas. This band music was very popular with those attending grandstand programs, and some visitors were very disappointed when the concerts were discontinued due to budget restraints.

The advent of better television programming and the increased competitions for the entertainment dollar were having a negative effect on grandstand attendance. The decision was made to initiate presenting a different big-name entertainer each evening of the fair. These changes resulted in record grandstand attendance. Because it proved so successful, soon other fairs were following our example.

One of the first big-name entertainers was a young English pop star by the name of Elton John. It was the first state fair date he had ever played. Ken Fulk was the fair manager at that time and was elated upon signing this superstar. He immediately proceeded to print posters advertising this gigantic event. Kim Matifield, the booking agent in California, learned that advertising had been initiated for "John Elton's" visit to the Iowa State Fair. Mike North, the booking agent, quickly informed Mr. Fulk that his prize entertainer was Elton John and not John Elton. This didn't dim Ken's enthusiasm. New posters were printed, and of course, the concert was a great success. I only wish I had saved one of the posters with the wrong name.

I have enjoyed many memorable experiences through the years of being associated with the Iowa State Fair. Probably my favorite was being involved with the production of a Martha Stewart television show featuring the youth livestock and other competitive events at the Iowa State Fair. I spent several days assisting her staff shooting segments of the 4-H and open-class beef-judging portion of her show. The day Martha arrived at the fair, I had the

privilege of welcoming and escorting her to the livestock-judging pavilion for the shooting of her television show. I was featured with Martha as I explained to her television audience the different aspects of exhibiting and the procedure of beef animal judging. I was impressed with her professionalism and how easy it was to work with her. I was amazed at the number of my friends from all over the country who called to inform me they had seen me on the Martha Stewart show on national television.

Another enjoyable experience was a one-on-one conversation with Reba McEntire in her dressing room immediately following her grandstand performance. I thanked her for appearing at the Iowa State Fair and complimented her on her great talent and outstanding performance. Reba was quick to thank the Iowa State Fair for the opportunity to play at the fair.

And she was especially appreciative of the fans' response to her performance. I then mentioned I had seen her during the winter on a television show as a substitute co-host. Jokingly, I said if she couldn't make it as an entertainer, maybe she could make a career in television. Reba paused a second and then flashed a big smile and stated that she was quite surprised I had remembered viewing that show. She proceeded to explain in great detail her experience of appearing on that show. It was such a pleasure to visit with a famous entertainer who was so easy and entertaining to converse with.

On another occasion, I had the responsibility of meeting Anne Murray and her manager at the airport and transporting them to the hotel room. We enjoyed a delightful visit about Iowa and the Iowa State Fair. Traditionally, sometime during the concert, Anne passes out some of her trademark yellow roses to her fans. As I was enjoying one of my favorite entertainers' concert, much to my surprise, her manager found me and presented me with this beautiful yellow rose. He stated that Anne wished me to have this special rose as her personal way of expressing her gratitude for the genuine hospitality extended to her. You don't ever forget an experience like that.

Spending an afternoon touring the grounds on my golf cart with Jo Ann Castle, of Lawrence Welk fame, and her husband, Joe, was an experience in itself. Jo Ann is a very bubbly and full-of-life individual. I was surprised when they requested to see the Big Bull and Boar and visit the livestock area. I was amazed that Jo Ann requested that she and I pose with the Big Bull and Boar while her husband took our picture. We did the grand tour of the grounds. It was a fun-filled afternoon that passed all too quickly.

Of all the many important changes and improvements made through the years to the grand old institution called the Iowa State Fair, probably the two that had the most significant impact on its continued success was the

enclosing, remodeling and climatizing of the Varied Industries Building and the formation of the Iowa State Fair Blue Ribbon Foundation.

The fair board and management felt there was a need for an exhibition facility that would provide another source of revenue. After much research and discussion, the decision was finally made to remodel the Varied Industries Building rather than build in some other location on the grounds. The decision was based on several advantages—namely, location, size, availability of ample and accessible parking for large events and better utilization year round. It has proven to be a highly utilized facility and a great source of added revenue.

The formation of the Blue Ribbon Foundation and its success has been nothing short of remarkable and the envy of the fair industry. Since its conception in 1993, over $67 million have been raised to preserve the historical Iowa State Fair for future generations. The foundation was the salvation of preserving the treasured buildings on the National Registry of Historic Places.

The tremendous success of the Blue Ribbon Foundation can be credited to a very incredible and dedicated individual, John Putney from Gladbrook, Iowa. Because of his deep love and affection for the Iowa State Fair since his early childhood, Mr. Putney accepted the challenge as executive director, a position he still holds. The phenomenal success he has achieved has surpassed all expectations and needs to be applauded.

These are just a few of the many memories and highlights I've experienced these years of serving on the Iowa State Fair Board.

LEE KLINE

As a farm broadcaster on WHO Radio for a lifetime, I did spend a lot of time at the Iowa State Fair in the livestock barns, but not all—I was intrigued by the big-name stars who came to perform on the Grandstand Stage.

Conditions were often adverse; it could be very cold and windy or extremely hot and humid, with the noise of the midway close by.

The best example of that was Sonny and Cher. They put on two shows, the first at 6:00 p.m., just when the sun was still boring in from the western sky. They perspired their way through their big songs, including "I've Got You, Babe." Kathie Swift tells me they drew 26,200 persons to the two shows—a record that remains unbroken. At the close of their show, they trotted out their three-year-old daughter, Chastity, and the audience loved it! And it was

plain to witness, being there, that the performers fed on that enthusiasm—in spite of the heat, the humidity and the midway competition.

But they all came; at the height of their radio and television popularity, Bob Hope, the Smothers Brothers, Herb Alpert and the Tijuana Brass, Liberace, Eddie Arnold, Lawrence Welk, Johnny Cash, Roy Rogers and Trigger.

Tennessee Ernie Ford was at the top of his career, with his own television show and a big hit on the radio, "Sixteen Tons." That famous song opened with prominent finger-snapping. I asked Ernie Ford who did the finger-snapping. He replied, "That was me. When we recorded, I snapped my fingers to set the beat. The producer said, 'That's good, leave it in!'"

Andy Williams performed in 1965. I asked him, on my tape recorder, "When you are at the top, what is there to shoot for?" He replied, "It isn't the money, it isn't fame. What is exciting is working, doing the best shows we can do, every week. Of course, it is wonderful to be accepted, to be successful, but more important is having fun doing what you are doing. It is fun to do the shows…it is fun to make records…it is fun to be here at the fair! If I weren't making any money at all, I would still want to do this."

And Bill, I feel the same way. I spent a lifetime covering the Iowa State Fair as part of my job, but I was energized by the people, the sounds, all that food and all those performers!

DUFFY LYON

I guess I kinda' drifted into creating the butter cow many years ago. Me and my big mouth; I thought I could make it something very special, and state fair visitors have enjoyed it.

I rotate the cows each year, highlighting the six major breeds shown in Iowa and the United States each year. In college, I used to enjoy drawing horses, so the transfer to cows wasn't too hard. Christian Peterson taught me how to always try for reality in my work.

I always get questions about the butter. Well, after the fair, the butter cow gets taken down and put in five-gallon orange juice concentrate buckets and is frozen at Des Moines Locker. About three weeks before the fair starts, I begin working on it—thawing, smoothing, getting it workable. Then I take it out by the handfuls and start the "fun," slapping it on over a frame—and yes, it is cold work. I have to wear heavy jackets, as we want the butter to firm up quickly. I use twenty-five five-gallon buckets of butter for the cow.

I will always love working on the cow and other "special" butter creations, but gradually I am being replaced by an enthusiastic crew who will provide fairgoers of future years with some exciting creations. Who is this, you say? My youngest daughter, Sarah Doyle Pratt, and my two youngest grandchildren, Todd and Erin Lyon, are going to take over so we have a ready, anxious, talented crew to make sure the Iowa State Fair will always have its famous butter cow!

CARLA WOOD

My name is Carla Wood. My father was Carl Cardamon, who had a concession food stand at the fair since 1946, sixty years. My husband, Kirby, and I have taken it over. Bill Sr. will have a Coke when he sits in my dad's favorite chair in the shade, enjoying one of our famous Gizmo sandwiches. I remember as a child going to the state fair to "help" my dad. His stand has always been located at the southwest corner of the Administration Building. The Plaza Stage, which is now the Bill Riley Stage, is right in front of us. At that time, the talent show used to give away a car as the grand prize. That car would be parked next to my dad's stand throughout the eleven days of the fair. I couldn't wait to see who would get to drive off in it. As the years passed, the grand prize changed, as well as the Plaza Stage. In 1996, my dad, Carl Cardamon, Bill Riley and Doc Cunningham all celebrated fifty years of being part of the Iowa State Fair. That was the first year my husband and I were shown the ropes by my dad. I will never forget when Simon Estes sang at the Bill Riley Stage to celebrate Bill's fifty years. There were thousands of people standing around our stand to try to get a glimpse and hear Mr. Estes perform. It truly was a magical moment. As the years passed, my dad's health started to deteriorate, but he would always be at the fair, no matter how he felt. My dad and Bill Sr. would sit on my dad's bench under a big shade tree and visit. Dozens of people would stop by to say hello to both of them. The fair was something my dad looked forward to throughout the whole year.

My dad passed away in 2001, but we still keep his bench out with his name on it. Now, we've celebrated sixty years at the Iowa State Fair, and I will look at that bench and know my father is sitting there next to Bill sharing stories and memories.

19

FAMILY STORIES

MEMORIES FROM BILL JR.

Many of Dad's projects are well known and are still in use today. The Blank Park Zoo, the Science Center, numerous bike trails and, of course, the *Talent Search*, which celebrated its fiftieth season during the 2009 Iowa State Fair.

Although he and Mom spent their winters in Arizona, which he loved, there wasn't anything that would keep them from their lake home in Clear Lake. Come April, they would have had enough of the big city pace and head for home. Talk about contrast! Four million people in the Phoenix area down to Clear Lake, where you can walk to church and get coffee on the way home. They truly lived the "Life of Riley." Dad always mentioned that he was the luckiest guy on the planet, and it's hard to disagree.

What most people don't know about Dad is what fun he was. He had a great sense of humor that was always in play. Always in good fun but always in play. Even when things were not going well, for whatever reason, he always had an optimistic spin on the situation. I could go on and on, but I thought it would be fun for all five of the Riley kids to put together a bit of a summary of life with Dad. Probably more like a roast! Here is a small synopsis of life with Bill Riley:

We always had pets. Always. Mynah birds, parrots, tropical fish, hamsters, but most of all dogs. We always had a dog in the house.

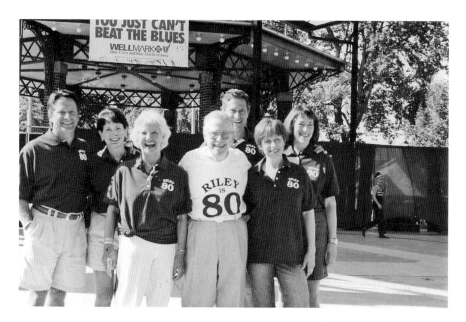

The Riley family, *from left to right*: Bill Jr., Peg O'Connor, Anne, Bill Sr., Edward, Terri Masteller and Patricia Savage.

My brother Ed hooked up one of the first stereo receivers I had ever seen in a linen closet in the upstairs hallway. That was because Dad wanted a headphone jack placed on his headboard so he could listen to music in bed! I can honestly tell you that he did listen to some of our music. He loved the early Johnny Winter works, Jethro Tull, Emerson Lake and Palmer and Cream. He wasn't crazy about Janis Joplin but commented that anyone that sounded like that will do something sometime.

I was privileged to see an amazing list of live acts—some with Dad taking me, but most of them were because my brother and sisters let me tag along. Dolly Parton and Porter Wagoner. Diana Ross and the Supremes. My sister Pat took me to see the Temptations! And many, many rock artists. Dad and Mom both realized that the more exposure to every type of music, the better.

There were music lessons for all of the children, with Ed being the only one with any talent.

Although he worked in radio since its early years, Dad rarely listened to it. He really didn't like the current "talk radio" style. "Too loud. They don't respect their audience," he would clamor.

Same with television. He never watched much, except for the Phoenix Suns and the weather channel. Other than his computer printer, the Weather Channel was by far the greatest thing ever invented!

He loved to eat but couldn't cook to save his life. Although he lived on a golf course in Arizona, Dad never owned a club. He lived on Clear Lake but didn't own a boat. What he did love was big band, swing music and dancing with his bride, Helen Anne.

He was always way too excited about any of the children becoming old enough to drive. This was very puzzling until we found out that we were enlisted as drivers to all the talent shows in the state.

Dad had a horrible sweet tooth. He always brought home goodies from the small towns. Pie, home-baked goods and, of course, fudge. He would walk across hot coals for homemade fudge!

He loved riding his ten-speed Schwinn while Mom was a Dawes Realm rider. This was before the time of cycling shorts, shoes with cleats, helmets, jerseys with food in the pockets or sport drinks before and after a ride. One time, he challenged me to see how fast I could ride my bike around Clear Lake. I did it in a little under two hours. I was twelve or thirteen. I can do it now in fifty to fifty-five minutes (must be the shorts and shoes). We rode to Iowa Falls one day with my best friend, Bob Dorweiler. After taking a break in some field, Dad exclaimed, "C'mon boys, if we don't get back on these bikes we will never get up!" We rode close to sixty-five miles in blue jeans and cut offs—oh my! We finally made it to Iowa Falls and to the grand opening of a new Kum and Go station on Washington Street. Of course, Dad was all excited and full of energy. Bob and I were never happier to see a Kum and Go in our lives!

Dad never complained about being short; in fact, he reminded us that he was five four and three-quarters—and we never were to forget the three-quarters.

He wasn't very handy around the house. Once he took the bathroom door off the hinges in an attempt to cut off the door to keep it from rubbing on the floor, only to cut the top of the door off. With Ed and me intently watching the "Master Carpenter," he quietly put it back on the hinges and never touched it again. It still rubbed on the bottom, but now you could throw a magazine in over the top.

Gardening was a big love. Peppers, carrots and his favorite, big tomatoes. We always had a garden. He would always love to pick the fruits of his labor.

He coached Ed and me in basketball at St. Augustine's Catholic grade school. He had a mean two-handed underhand set shot. Used to drive us nuts the way he would drain fifteen-footers with ease!

Of course, he was very competitive. He enjoyed playing ping pong with us, and while we would always try to kill the ball, Dad would merely play

defense and return the shot, with a comment like, "This really is a fun game isn't it?" or "You look like you're getting tired."

He drove Ed's rock band the Penny Arcade all over the place and was instrumental in starting the battle of the bands at the fairgrounds. Many of the winners would then appear on television. We are now back to that point with music. What were called "combos" in the 1960s are now "garage bands." Great music then and now. Thank goodness!

We owned one of the first VWs in the early '60s, as well as a 1965 Ford Mustang fast back—white with a black interior, 289-V-8. I wish we still had both of those cars.

We always went on trips to the western United States, including Mesa Verde, Zion, Grand Canyon and Yellowstone. Mom would strategically dispense Dramamine so at least three of the five children were either out cold or barely able to keep our eyes open. They would put a mattress in the station wagon, and off we would go, leaving Forty-fourth Street around 3:00 a.m. We all would wake up in Estes Park or somewhere and wonder what the heck happened. We have some great memories of camping.

MEMORIES FROM PAT

I remember we got our first TV set, and I helped Dad do the first Annie Oakley television show when television was just coming to Des Moines. I remember he would chart his stocks in a book and teach me how to play the market. I remember he would have dramatic Christmas home movies with all of us coming down the stairs. I remember the fabulous long California trips. Mom talked him into traveling by camping; I think that is why Dad would always get a hotel room in Vegas. We were visiting Disneyland the year it opened—because he gave away a free trip to Disneyland for some promotion. I remember when we stopped at a gas station and left Ed in the restroom only to have a guy on a motorcycle pull up beside us with Ed on the back, crying. Dad would always come and wake Mom and me up and send us down to the living room to catch the bats. He would be barking orders from the landing that we were not to kill the bat, only catch it and let it go. I remember finding lots of frozen candy bars in the basement freezer and chocolate-covered cherries in his dresser drawers. When Mom would tell us to put the laundry away, we found his stash. When I started to date, he would set an alarm clock by the door so I wouldn't be late. I miss him so much.

MEMORIES FROM ED

I remember the annoying 8-millimeter movie camera with the bank of six to eight spotlights. On Christmas morning, we would all have to wait at the top of the stairs and then proceed down and pretend to not look like we were being blinded by ten thousand kilowatts of light.

One of my favorite memories was when Dad took me out to teach me tennis. We were at the Waveland public courts, and he was showing me how to hit the ball by chopping at it. Now remember how much Dad played tennis (that would be zero). All I know is he played in college, but he made the team by *forming* the team. The college didn't have a tennis team at the time, so he and some buddies formed one. Voila, instant college tennis phenom. So here I am, a blank tennis canvas in the hands of Bill "the Chopper" Riley. As I listened to the expert instruction, my mind began to become distracted by the other seasoned tennis players on the other courts, taking full swings at the ball, generating lots of topspin and incredible pace on their shots. I remember saying to my dad, "I want to learn to hit like those guys." The response I got was that in order to learn any game the right way, you need to listen to your coach.

MEMORIES FROM TERRI

I remember being little and telling Dad that there were mice in the walls. He got mad and made me go back to bed. Finally, he came and sat on the bed and heard mice crawling in the walls, and he just about flew out of the room!

MEMORIES FROM PEG

Even as a little girl, I remember how loving my dad was. We would always wait by the front door for him to come home from work. Sometimes he would sit in a chair and read the newspaper, and we would take turns sitting on his lap. A very poignant lesson learned during one of my lap-sitting adventures was to not eat hard candy in his ear. That would get you removed from the lap quicker than anything. He loved all of us and wasn't shy at letting us know. And as for our mother, he would dance around the kitchen with her and was always telling her how beautiful she was (and she was).

Patience was probably his greatest virtue, especially having to deal with five kids at home after a long day. He always made everything seem easier, like when he was teaching me how to ride a bike or trying to get me to master the shifting of gears in our VW. I did eventually become quite good at VW driving. I remember one time, the brakes were going out in that VW, so he had me drive to Drake. He sat in the passenger side and said, "Don't worry, shift as usual, but when we come to a stop sign, downshift and just let up on the gas." I did as I was told, and he proceeded to use the hand brake that was located in between the front seats. We would come to a screeching halt. It worked well, and he dropped me off at Drake. I have no clue how he made it to work after that.

He was a very calm disciplinarian when he needed to be. For example, when my youngest brother, Bill, loaded his wagon with candy that was supposed to be used for his work engagements (Red Ball Jet shows or *Talent Shows*) and proceeded to go up and down Forty-fourth Street and sell it to our neighbors at a much-discounted rate. Or when eldest daughter, Pat, decided to see if the advertisement claim made by the Volkswagen company was true: "They are so air tight that the car can actually float." She, along with her friends, tried to float a VW (not ours) in Clear Lake. Needless to say, it held up to the claim for about fifteen minutes and then sunk! Yes, we all had our deep disciplinary "discussions" with Dad.

He was a humanitarian at heart and donated many hours personally. He was always enlisting his own children to volunteer their time. But he had an uncanny knack for getting others excited about his passions and getting the children around Des Moines involved for the betterment of their communities.

Early on in his broadcasting career, he, along with other KRNT staff, held Saturday morning shows at the KRNT Theater. The shows were supposed to be a place where kids could come, have fun and be safe, and safety was the theme. He had a big dummy called Hey Bob that the kids all loved. Bob stood for "Be on the Beam," meaning be alert when playing, riding your bike, et cetera.

Then came raising money for the first Science Center of Iowa and the Blank Park Zoo. He was able to utilize his position on the radio and television to allow supporting these great organizations. He had kids bringing their piggy banks in to donate to the cause. He raised thousands of dollars.

How about the bike trails around Iowa? My dad was one of the first people to begin the call for action in developing bike trails. He was always holding events to raise money to support Iowa bike trails. There is a trail named after

him that begins near the Ashworth Swimming Pool in Greenwood Park in Des Moines—a beautiful, wooded ride.

He and my mother also gave large endowments to their hometowns of Clear Lake and Iowa Falls to be used by each city for the enjoyment of their townsfolk. And they both supported one of their very favorite places, the Iowa State Fair—thus the Anne and Bill Riley Stage, which is the home stage of the *Talent Search* to this day.

My dad was also a very funny guy and had a great sense of humor. He would tell jokes at the dinner table, move fruit around in the fruit bowl and make funny displays. One time, he took the big dummy Hey Bob out of the attic and kept moving him to different locations around the house. You would turn on the light in the room and be scared to death. He thought that was so funny.

In later years, he dubbed our family lunches the "Tiny Magoo Luncheon Club," which was named after my daughter Megan. He had little pet names for all of the grandkids.

I spent many hours working with my dad. I used to pack up my books and head down the road with him to all of the small rural Iowa towns for talent shows. I would usually drive to the show, and then I would do my homework while he worked the talent show. Needless to say, I didn't get much homework done because, on those occasions, I was too busy watching all the great talent. Then he would drive home, as we were usually heading home around 10:00 p.m.

I spent many Saturdays signing up three to four hundred children during his events for his sponsor Red Ball Jets. Children would stand in line for hours to see my dad and receive free candy. I always thought that was amazing that so many would come out to see my dad. I didn't realize until later how really special he was.

I also worked with him on Saturday mornings on the radio. He had a show called *Party Line* and a couple of other radio shows. In between calls, he would read the football or basketball scores. I was the runner from the basement of the station—where the teleprompter with information from API and UPI was located with the scores coming in—to the second floor, where his show was on the air. Things would have been much easier if we had computers or cellphones. That was a tiring job.

I worked the *Talent Search* once it started to be aired on TV. I was behind the scenes getting the next act ready and in place to begin. Then I would hold cards up to prompt the audience when to clap at the end of an act. The sprout acts were the most fun.

My last job with Dad was with the Blank Park Zoo. I worked at the zoo and would bring animals each week with Mr. Elgin to show on Dad's Saturday morning show. On one Saturday, Mr. Elgin requested that I drive the tiger cubs in their cages back to the zoo in the zoo station wagon, as he had another meeting to attend. I agreed, and once the cubs were loaded, I took off heading toward the zoo. I kept thinking that I was seeing things moving while I was driving and then felt as though something was on my neck. The tiger cubs were quiet. I kept driving and finally came to a stoplight. I turned my head to look at the cubs and noticed the hay bales that were in the tiger cages were full of cockroaches. I did finally make it back to the zoo with numerous stops to debug my front seat. That was my last animal-chauffeuring trip.

My dad was a great father and grandfather, and there are way too many wonderful memories to list. He has been greatly missed, not only by his family, but by all who were touched by him.

I love you, Dad!

20

IN CONCLUSION

As they say in show business, the great curtain in the sky is slowly descending. No one is more conscious of that sobering fact than I.

So as I finish this effort to capture a few memories from the past sixty years, I really hate to face the reality of the obvious finality. I have never been one to give up, but the time has come.

What a ride it has been! Through all these many years, I never remember a day that I have not hit the floor running, always with some project to kindle my fire, even as I come to this moment and bring this book to a close.

With the thank-yous, I must add thanks to my Clear Lake beauty Helen Anne Hanson, my wife of nearly sixty-two years. I certainly could not have been constantly on the go for every day through all these years without Anne Riley's steadfast support and encouragement. What a fabulous girl she was as a sixteen-year-old junior in high school when I first saw her. It was at a teenage dance in Alden, Iowa, one Friday night in September 1939. I loved to dance and was in attendance with friends from Ellsworth College in Iowa Falls, my home, just five miles from Alden.

I will never, ever forget that night as we watched a group of Alden girls enter the Legion Hall—and with them a girl whom I thought was the cutest I had ever seen. It was Anne Hanson, whose dad had transferred to Alden from Clear Lake that fall. After a dance or two, I was convinced she was indeed as much of a super girl as she was a fine dancer. I found out later that she learned to dance at the Surf Ballroom.

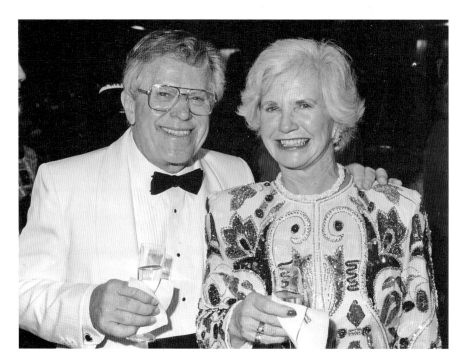

Bill and Anne Riley.

I won't bore you with any more details, but five years later, on February 3, 1945, Anne and I were married at St. Ambrose Cathedral in Des Moines. Would you like to know what we did on our honeymoon night? Well, after a wedding luncheon, we boarded the Rock Island train for Iowa City, where I joined Jon Hackett to broadcast the Iowa-Michigan basketball game on KRNT Radio. By the way, Michigan won.

I still can't understand how those Clear Lake and Mason City boys let this homecoming queen be stolen away by an Iowa Falls boy!

Anne and I are blessed with five wonderful children—Patty, Peg, Terri, Ed and Bill Jr.—and I am happy to say they get along just great and enjoy one another's company. Anne and I are so proud!

As I wind down this most fabulous life, I could not have asked for anything more. Thank-yous would have to go out by the hundreds for those who have helped along the way. It has been a fantastic ride!

And now, I pass the baton to Bill Jr., who has already taken over the talent show for the past several years and has made it even bigger and better than before as he approaches the fiftieth anniversary of the show in a few short years. As Anne Riley once said, "Billy does a great job as

your replacement...he actually does better than you ever did!" That's a mom for you.

It is reported that Indians hate to say goodbye and instead will say until we meet again. And now the curtain has come all the way down. So, until we meet again.

Appendix

BILL RILEY
TALENT SEARCH WINNERS

1960 Bill Bond and Jeff Jeffries, Accordion Duet
1961 The Surber Sisters, Linda, Carolyn, Virginia and Phyllis, Gospel Quartet
1962 Susan Hoopes, Vocalist
1963 Jack Briggs, Vocalist
1964 Beverly Meyer, Ventriloquist
1965 Duilio Mordini, Accordionist/Vocalist
1966 Denny Naughton, Ventriloquist
1967 Bill Lauritzen, Vocalist
1968 Kay Bruce, Acrobat
1969 Dave DeHamer, Vocalist
1970 Kim Sienkiewiz, Vocalist
1971 Linda McDonald, Vocalist
1972 Bill Nolan, Vocalist
1973 Patti Whiting, Vocalist
1974 Linda Wilson, Baton
1975 Joel Mosher, Vocalist
1976 Bill Whittenberg, Vocalist
1977 The Poyner Twins, Kim and Kern, Ventriloquists
1978 Paul Munsen, Magician
1979 Linda Wadle, Vocalist
1980 Alan Cemore, Vocalist

1981 Anthony Turner, Vocalist

1982 The Buffalo Heads, Doug Cline, Dennis Goodwin, Tom Lee and Aaron Kjenaas, Vocal Quartet

1983 Heidi Brende, Pianist

1984 Vocal Minority, Doug Morse, Dennis Lee, Brad Wright and Brett Baker, Vocal Quartet

1985 Katy McGee, Modern Jazz Dance

1986 James Leonard, Vocalist

1987 David Raim, Vocalist

1988 Charlotte Brekke, Lyrical Ballet

1989 Andrew Tam, Pianist

1990 Mistie Metten, Pointe Toe Dancer

1991 Mark Wilson, Vocalist

1992 John Osborn, Vocalist

1993 Chad Trierweiler, Tap Dancer

1994 Bryan Eyberg, Pianist

1995 Jennifer Wibben, Flutist

1996 Lisa Dondlinger, Violinist

1997 David Swindler, Pianist

1998 Eddie Neimann, Pianist

1999 Luke and Jamie Freml, Tap Duet

2000 Chris Petersen, Tap Dancer

2001 John Moore, Vocalist

2002 Thomas McCarger, Vocalist

2003 Alexander Van Dorpe, Cellist

2004 Diana Reed, Baton

2005 Stephanie March, Cellist

2006 Amanda Hardy, Oboist

2007 Zach Villa, Tap Dancer

2008 The Offbeats, Adam Bogh, Alex Bogh, Michael McAndrew, Michael Penick and Jeremy Gussin, Vocal Quintet

2009 Paul Child, Pianist

2010 Isaac Stauffer, Tap Dancer

2011 Chelsea Wang, Pianist

2012 Micah Wright, Clarinetist

2013 Adrian Oldenburger, Ballet Dancer

2014 Roberto Gemignani, Pianist

2015 Britta Fults, Vocalist

INDEX

ABOUT THE AUTHORS

BILL RILEY

Bill Riley Sr. spent sixty years in radio and television and at the Iowa State Fair. He was the founder of the *Bill Riley Talent Search*, which is now in its fifty-seventh year. Many people knew him as "Mr. Iowa State Fair" or the "Voice of the Drake Relays." Bill and his wife, Anne, had five children. After retiring, Bill and Anne split their time between Arizona and Iowa.

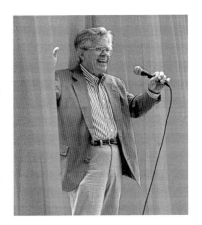

HEATHER TORPY

Heather Torpy is the vice-president of the *Bill Riley Talent Search*. Before that, she was at the CBS affiliate in Des Moines, KCCI, for twelve years. Heather's writing can also be found in the *Des Moines Register*. She is a lifelong Iowan and lives in Urbandale with her husband and children. She is an avid reader and cook and continues to try to improve her score on the golf course.